CONSTABLE'S ENGLAND

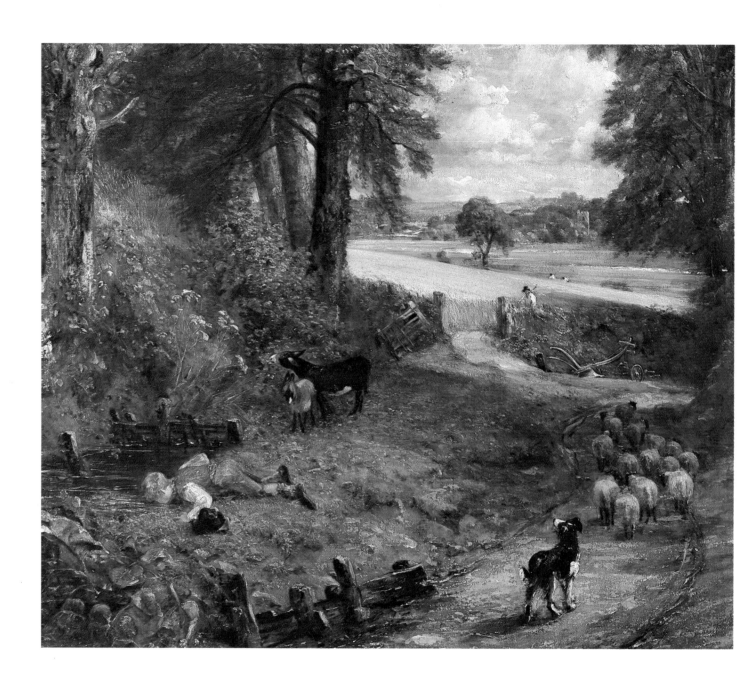

CONSTABLE'S ENGLAND

by Graham Reynolds

The Metropolitan Museum of Art · New York
WEIDENFELD & NICOLSON · LONDON

Published in conjunction with the exhibition "Constable's England" held at The Metropolitan Museum of Art, New York, April 16–September 4, 1983.

The exhibition, sponsored by James D. Wolfensohn Incorporated, Johnson Wax, Lex Service Group PLC, and The Starr Foundation, with additional generous support from the Honorable and Mrs. Walter H. Annenberg and Enid A. Haupt, is a part of the BRITAIN SALUTES NEW YORK 1983 festival. An indemnity has been granted by the Federal Council on the Arts and Humanities.

Published in association with
The Metropolitan Museum of Art, New York,
by George Weidenfeld & Nicolson Limited
91 Clapham High Street
London SW4 7TA
ISBN 0-297-78359-9

Designed by Katy Homans

Typeset in Bembo by U.S. Lithograph, New York
Manufactured by Albert Hentrich oHG, Berlin
Printed in the Federal Republic of Germany

COVER/JACKET
The Stour Valley and Dedham Village (No. 15), detail

FRONTISPIECE
The Cornfield (No. 23), detail

Reproductions are by permission of the owners or custodians of the original works, who supplied photographs and color transparencies except in the following cases: The Bridgeman Art Library (19), A. C. Cooper (Colour) Ltd. (7, 55), The Medici Society Ltd., courtesy Thos. Agnew & Sons Ltd. (57), Tom Scott (18), Eileen Tweedy (4, 10, 35, 36, 40, 50).

Sketch map by Kathleen Borowik.

Measurements in the catalogue are given in inches and centimeters; height precedes width.

CONTENTS

Figs. 1–18 between pp. 12 and 28
Sketch map. Constable's England, with inset of the Constable country 178

LENDERS

BIRMINGHAM
Birmingham Museums and Art Gallery,
 anonymous loan 22

BOSTON
Museum of Fine Arts 15, 29

CAMBRIDGE
Fitzwilliam Museum 30, 32

CHICAGO
The Art Institute of Chicago 60

CINCINNATI
Cincinnati Art Museum 54

CLEVELAND
The Cleveland Museum of Art 46

DETROIT
The Detroit Institute of Arts 52

EDINBURGH
National Gallery of Scotland 18

EGHAM
Royal Holloway College, University of
 London 19

IPSWICH
Ipswich Museums and Galleries 16

KANSAS CITY
Nelson Gallery-Atkins Museum 62

LEEDS
Leeds City Art Galleries 13

LONDON
Courtauld Institute Galleries, University of
 London 44
The Trustees of the National Gallery 23
Royal Academy of Arts 5, 24, 37, 39, 50, 53
The Trustees of the Tate Gallery 6, 25
Victoria and Albert Museum 4, 10, 14, 35,
 36, 40, 47

MANCHESTER
City of Manchester Art Galleries 38

MANCHESTER, NEW HAMPSHIRE
The Currier Gallery of Art 17

NEW HAVEN
Yale Center for British Art 1, 8, 20, 33, 41,
 43, 51, 56, 58

NEW YORK
The Metropolitan Museum of Art 34, 59

OTTAWA
National Gallery of Canada/Galerie Nationale
 du Canada 31

No. 31 will be withdrawn from exhibition after July 3 and No. 26 after July 31, 1983.

FOREWORD

When plans for the festival BRITAIN SALUTES NEW YORK 1983 were under discussion, it seemed appropriate that one of the events should be an exhibition at The Metropolitan Museum of Art devoted to "Constable's England." This is indeed the first major exhibition of the paintings of John Constable ever to be shown in the United States. We are the more fortunate, therefore, in having been able to entrust the shaping of the exhibition and the writing of this catalogue to Graham Reynolds, the leading specialist on Constable. Formerly Keeper of Paintings, Prints and Drawings at the Victoria and Albert Museum, Mr. Reynolds, in addition to his other responsibilities, had charge of the museum's great Constable collection given almost in its entirety by Isabel Constable, the artist's daughter; his catalogue of that collection, first published in 1960, is the most important single contribution to our knowledge of the artist's work. Mr. Reynolds is also the author of an excellent general volume, *Constable: The Natural Painter*, and has recently prepared for the Paul Mellon Centre for Studies in British Art one of the two volumes of a forthcoming catalogue raisonné of Constable's work. He will lecture on Constable at the Metropolitan Museum in April 1983 under the auspices of the annual Helen and Leonard Yaseen Studies lectures.

The pictures in this exhibition, ranging from small oil sketches done in the open air to finished paintings on a large scale, have been selected to show not only the landscape subjects that Constable chose to paint but also the full scope of his remarkable development as an artist. They begin with a sketch of his Suffolk countryside made around 1802, when he was in his twenties, and end with the canvas upon which he was working on the day he died in 1837. A number of paintings are juxtaposed for the first time since they left the artist's studio. These include two versions of *Helmingham Dell* (Nos. 61, 62), one owned by the John G. Johnson Collection in Philadelphia and the other by the Nelson Gallery-Atkins Museum, Kansas City, and the sketch and final version of *Arundel Mill and Castle* (Nos. 63, 64), lent respectively by the Fine Arts Museums of San Francisco and the Toledo Museum of Art, Ohio.

This tribute to Constable owes much to the good will of lenders on both sides of the Atlantic, whose names are listed separately, and to the cooperation of many individuals and organizations. In Great Britain our prime debt is to the President of the Royal Academy, Sir Hugh Casson, who has supported the exhibition from its inception with great enthusiasm, and to the Council of the Royal Academy, which has authorized a number of important loans from its collection. We are also indebted for the loan of major works to the Directors and Trustees of

· 9 ·

the National Gallery, the Tate Gallery, and the Victoria and Albert Museum, and to the Principal of the Royal Holloway College. In this country no fewer than nine paintings have been lent by the Yale Center for British Art. Important loans have also been made by the Boston Museum of Fine Arts, and the Philadelphia Museum of Art and the John G. Johnson Collection. The exhibition will not travel, and the showing in New York is therefore of exceptionally long duration. We are the more indebted to the generosity of Henry P. McIlhenny and of five private owners who wish to remain anonymous. At the Metropolitan Museum arrangements for the exhibition and for the catalogue, edited by Mary Laing, have been coordinated by Katharine Baetjer, Curator of European Paintings.

In funding the exhibition the Museum has had assistance from various sources. An indemnity has been granted by the Federal Council on the Arts and the Humanities. The exhibition has been made possible by grants from James D. Wolfensohn Incorporated, Johnson Wax, Lex Service Group PLC, and The Starr Foundation, and through the generosity of the Honorable and Mrs. Walter H. Annenberg and of Enid A. Haupt.

<div align="right">
PHILIPPE DE MONTEBELLO

Director

The Metropolitan Museum of Art
</div>

AUTHOR'S NOTE

The excerpts quoted from Constable's correspondence and other writings are taken from the volumes edited in the main by R. B. Beckett and published by the Suffolk Records Society. I have not, however, thought it necessary to preserve all the vagaries of Constable's frequently erratic spelling and punctuation.

A few suggestions for further reading about Constable's life and work are given at the end of the volume. In the catalogue, references to previous literature have been confined to a minimum of recent publications. Fuller references and discussion will be found in the forthcoming catalogue raisonné of all Constable's known works, written by Charles Rhyne for the years up till 1816 and by myself for the years 1817–37.

<div align="right">
GRAHAM REYNOLDS
</div>

ABBREVIATIONS

Boston, 1946

An Exhibition of Paintings, Drawings and Prints by J. M. W. Turner, John Constable, R. P. Bonington. Boston: Museum of Fine Arts, 1946.

Chicago/New York, 1946–47

Masterpieces of English Painting: William Hogarth, John Constable, J. M. W. Turner. Exhibition catalogue. The Art Institute of Chicago/The Metropolitan Museum of Art, New York, 1946–47.

COLL.

Collections. The previous ownership of each painting is given as fully as our present knowledge allows.

Detroit/Philadelphia, 1968

Cummings, Frederick, and Staley, Allen. *Romantic Art in Britain.* Exhibition catalogue. The Detroit Institute of Arts/Philadelphia Museum of Art, 1968.

EXH.

Exhibitions. Only those that took place in the artist's lifetime are listed under this heading. References to other exhibitions are confined to recent events of special importance, with a published catalogue, and are given under LIT.

H.

Hoozee, Robert. *L'opera completa di Constable.* Classici dell'arte. Milan: Rizzoli, 1979.

JCC

John Constable's Correspondence, ed. R. B. Beckett.
 I. *The Family at East Bergholt, 1807–1837,* 1962.
 II. *Early Friends and Maria Bicknell (Mrs. Constable),* 1964.
 III. *The Correspondence with C. R. Leslie, R.A.,* 1965.
 IV. *Patrons, Dealers and Fellow Artists,* 1966.
 V. *Various Friends, with Charles Boner and the Artist's Children,* 1967.
 VI. *The Fishers,* 1968.

JCD

John Constable's Discourses, ed. R. B. Beckett, 1970.

JC:FDC

John Constable: Further Documents and Correspondence, 1975.
Part I. *Documents,* ed. Leslie Parris and Conal Shields.
Part II. *Correspondence,* ed. Ian Fleming-Williams.

JCC, JCD, JC:FDC. Ipswich: Suffolk Records Society.

LIT.

Literature. References are confined to recent publications of particular relevance, including catalogues of exhibitions in the United States in which Constable's work has been represented.

New York/St. Louis/San Francisco, 1956–57

Ritchie, Andrew Carnduff. *Masters of British Painting 1800–1950.* Exhibition catalogue. The Museum of Modern Art, New York/The City Art Museum of St. Louis/The California Palace of the Legion of Honor, San Francisco, 1956–57.

P.

Parris, Leslie. *The Tate Gallery Constable Collection.* London: Tate Gallery, 1981.

R.

Reynolds, Graham. *Victoria and Albert Museum: Catalogue of the Constable Collection.* London: Her Majesty's Stationery Office, 1960; 2nd ed. 1973 (the numbering is the same in both).

Richmond, 1963

Taylor, Basil. *Painting in England 1700–1850.* Catalogue of the exhibition of the collection of Mr. and Mrs. Paul Mellon. Richmond: Virginia Museum of Fine Arts, 1963.

Tate, 1976

Parris, Leslie; Fleming-Williams, Ian; and Shields, Conal. *Constable: Paintings, Watercolours and Drawings.* Catalogue of the bicentenary exhibition. London: Tate Gallery, 1976.

Thornes

Thornes, John E. *The Accurate Dating of Certain of John Constable's Cloud Studies 1821/22 Using Historical Weather Records.* Occasional Papers No. 34. London: University College, 1978.

Washington, 1969

Watson, Ross. *John Constable: A Selection of Paintings from the Collection of Mr. and Mrs. Paul Mellon.* Exhibition catalogue. Washington, D.C.: National Gallery of Art, 1969.

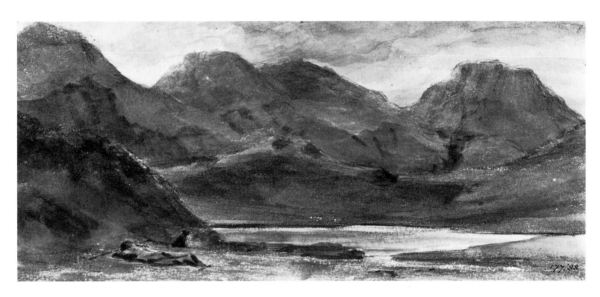

1. *Sty Head Tarn, Borrowdale*. Dated: *Sunday Octr. 12 1806 — Noon*. Pencil and watercolor, 4¾ x 10⅝ in. London, Victoria and Albert Museum

INTRODUCTION

IN CONSTABLE'S TIME England was divided into thirty-nine counties. Constable set foot in just over half of them; he never crossed the borders into Wales or Scotland, still less did he travel out of the country, even when his pictures were creating a furor in Paris in 1824. The scenes that enter significantly into his painting are drawn from an even more restricted area: the six counties of Suffolk, Essex, Middlesex, Wiltshire, Dorset, and Sussex. Geographically, "Constable's England" is a severely limited concept. In his concentration on a small number of places studied over and over again Constable presents a sharp contrast with his great contemporary Turner, who took not only England, Scotland, and Wales but also the whole of accessible Europe as his province.

Constable had discovered early on that it did not suit him to travel for the special purpose of finding paintable subjects. In 1801 he paid a conventional visit to the Peak District, an area described in glowing terms by the Reverend William Gilpin, the celebrated writer on the picturesque, as a key example of picturesque scenery. The drawings Constable did then are a mere pastiche of the style of his early tutor Sir George Beaumont, and he made no oil paintings from these scenes. Five years later he spent seven industrious weeks in the Lake District, another area favored by those in search of romantic effects. This visit had more substantial results. Working alone among the hills he made a number of somber, impressive watercolors (fig. 1), and for the first time inscribed weather notes on them. He exhibited oils based on some of these sketches at the Royal Academy in the years 1807 to 1809. Then the Lakes dropped completely out of his repertoire. He had discovered that he required an inhabited working landscape; "the solitude of mountains oppressed his spirits."

The England seen in this group of pictures is, then, essentially the pastoral southeastern corner of the country. The localities Constable chose to paint in his maturity were not suggested to him by the prevalent theories of good taste or picturesque discovery. He painted landscapes with which he felt a deep personal bond, places he had lived in, closely bound up with the history of his friendships and affections. To a greater extent than with most painters the history of Constable's subject matter is the history of his life. Suffolk and Essex were the counties of his childhood and earliest memories, Middlesex his home for the second half of his life, Wiltshire the home of his closest friend John Fisher.

Of all these areas by far the most significant was contained in a small circle around East Bergholt, Suffolk, where he was born on June 11, 1776. Known even in his own lifetime as

"Constable's country," it is a tract along the Suffolk and Essex borders and the seaward reaches of the river Stour. It is not a spectacularly interesting countryside, but it played a vital part in stimulating Constable's imagination. Later visitors have observed how much smaller in scale it seems in reality by contrast with the idea of it given by Constable's paintings; but in them he was building on the impressions he had formed as a child. His roots were firmly planted in this pastoral setting; his father was a well-to-do miller, owning the watermills at Flatford and Dedham. The gently sloping fields of Dedham Vale provided the grain for these mills and were fringed by grazing land for cattle and sheep. The produce was carried to the coast, for shipment to the London markets, by the slow-moving barges of the Stour, a waterway which was the focus of Constable's childish vision and the major theme of his most ambitious paintings.

The political journalist and reformer William Cobbett was no friend to East Anglia, which he thought had become unfairly prosperous through the impact of the Napoleonic Wars. Even so, he recognized the abilities of its farmers and the good husbandry they displayed. After visiting Ipswich in 1830 he wrote:

> You can, in no direction, go from it a quarter of a mile without finding views that a painter might crave, and then the country round about it so well cultivated; the land in such a beautiful state, the farmhouses all white, and all so much alike; the barns, and everything about the homesteads so snug; the stocks of turnips so abundant everywhere; the sheep and cattle in such fine order; the wheat all drilled; the ploughman so expert; the furrows, if a quarter of a mile long, as straight as a line, and laid as truly as if with a level: in short, here is everything to delight the eye, and to make the people proud of their country; and this is the case throughout the whole of this county. I have always found Suffolk farmers great boasters of their superiority over others; and I must say that it is not without reason. (*Rural Rides*)

Cobbett also noticed that the price of grain in the Ipswich market was six shillings a quarter higher than in Norwich because the navigation to London was so much quicker and safer.

Constable had his own share of Suffolk obstinacy and pride of place. He quoted the story of the laborer who, when crossing the Stour into Essex in search of work, looked back at Suffolk and said, "Good-bye old England, perhaps I may never see you any more." When he was refusing to visit Paris to share in the triumph of *The Hay Wain* at the Salon of 1824, he wrote: "Think of the lovely valleys mid the peaceful farm houses of Suffolk, forming a scene of exhibition to amuse the gay and frivolous Parisians."

From 1808, with the scenery of the Lakes behind him, Constable concentrated on those peaceful valleys and well-kept farmhouses. He sustained until 1816 an intense and systematic

course of sketching in oils in the open air in a renewed and successful attempt to become a "natural painter." Even within the short reach of the Stour between Flatford and Dedham he was selective in his choice of scene; his main subjects fall into a cluster around Flatford Mill and Lock in the east and Dedham Mill and Lock in the west. The examples of his open-air sketching in this exhibition show how sensitive he had become to atmospheric effect, and under what varied conditions he pursued this self-imposed regimen of study. His subject was not simply the landscape; it was also the light in that landscape, in which he studied equally the sparkling dews of early morning, the serene radiance of noon, and the long shadows cast by the declining evening sun.

In the late eighteenth century, as now, London was the cultural and artistic hub of England. It was the center for exhibitions, the meeting place for collectors and dealers, the source of instruction. When Constable decided to become a professional painter in 1799 (fig. 2), he was obliged to spend a substantial proportion of his time there, attending the Royal Academy schools, meeting his colleagues, and forming associations that might be of value in furthering his career. Gradually he fell into a routine, passing the winter months in London and his summers in East Bergholt. By 1810 his dedication to the country had become more intense; his courtship of Maria Bicknell, opposed by her family, ran a long and discouraging course, and his parents were in the last years of their life.

In May 1816 Constable's father died, an event which gave him some degree of financial independence, and later that year he married Maria Bicknell (fig. 3). This caused a radical change in his way of life and led to a considerable expansion of the topographical range of his painting. Till then he had been a lodger in London with his heart in the country. Now London was to become his home, the center for himself, his wife, and their growing family. For many years his visits to East Bergholt were confined to hasty journeys on business matters. Although he attributed the whole bent of his mind and the course of his career to his rural upbringing, he scarcely provided an equivalent opportunity for his children. It was not till 1827 that he took any of them to Suffolk for a holiday. His daughter Minna showed her ignorance of the country by saying that it was "just fields": to her, Suffolk was like Hampstead, except that the blackberries were much finer. Events had caused Constable to move beyond his early range of interests, to make new friends and to find other landscapes.

One of the earliest occasions for the enlargement of his scope came with marriage. He had met the Reverend John Fisher, nephew of the bishop of Salisbury, on his first visit to the cathedral city in 1811, and they had become fast friends. After conducting their wedding ceremony on October 2, 1816, in St. Martin-in-the-Fields, London, Fisher invited John and Maria Constable to spend part of their honeymoon at his country vicarage at Osmington, beside the Dorset

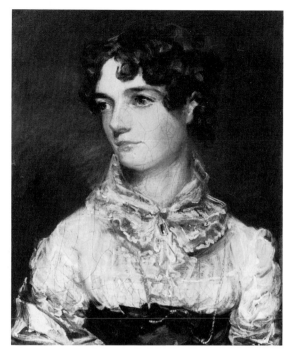

2. Ramsay Richard Reinagle (1775–1862), *John Constable*, ca. 1799. Oil on canvas, 30 x 25⅛ in. London, National Portrait Gallery

Reinagle and Constable were fellow students at the Royal Academy in 1799.

3. *Maria Bicknell, Mrs. John Constable* (1788–1828). Dated: *July. 10 1816*. Oil on canvas, 12 x 9⅞ in. London, Tate Gallery

The portrait was painted by Constable a few months before their marriage.

coast. Although it was late in the year Constable made many drawings (fig. 4) and some oil sketches, such as the large and sharply observed *Weymouth Bay from the Downs Above Osmington Mills* (No. 29). He always thought of this coast with affection, but found no opportunity to return.

The association with Fisher had other, more lasting consequences. In 1820 a long, relaxed summer visit with his family to Leydenhall, his friend's house in Salisbury Close, gave Constable ample opportunity to sketch and draw the cathedral and its surroundings. On this and subsequent visits in 1821 and 1823 he extended his knowledge of Wiltshire and Dorset to encompass Stonehenge, Old Sarum, and Gillingham. The most significant result of these journeys was the composition *Salisbury Cathedral from the Bishop's Grounds*, the sketch for which, with a late, uncompleted version, is shown here (Nos. 31, 34).

Soon after their marriage Maria's health became a dominant factor in deciding Constable's

4. *Osmington Bay and Portland Island.* Dated: *Nov.* 7. *1816.* Pencil, 4½ x 7⅛ in. London, Victoria and Albert Museum

From the sketchbook Constable used during his honeymoon.

movements. Their married life was begun in Holborn at 1 Keppel Street, within convenient walking distance of the Royal Academy, then at Somerset House. The new Waterloo Bridge was opened in the same reach of the Thames and on his frequent visits to the Academy Constable was able to watch the progress of its construction. He also saw the opening ceremony and, after years of procrastination, finished his only large painting of a central London scene, *The Opening of Waterloo Bridge Seen from Whitehall Stairs, June 18th, 1817* (No. 57). But Maria was showing signs of an inherited tendency to tubercular consumption, and the air of Keppel Street did not suit her. So from 1819, in a first attempt to find healthy conditions for her and the children, Constable took lodgings in Hampstead. It was then a small village in fairly rural surroundings, about three miles from his London studio, on a low ridge overlooking the Thames Valley to the south and open country to the north and west. On the London skyline the dome of St. Paul's was a prominent landmark. Due west about seven miles away, Harrow Hill with its church was another feature that Constable included again and again in his sketches (Nos. 37, 38, 41); if Flatford was his Argenteuil, Harrow was his Mont-Sainte-Victoire. The position of Hampstead made it an admirable observatory for the study of cloud formations, and it was here that Constable embarked on the systematic recording of skies and their related weather that became such an original and important part of his practice (Nos. 39, 40, 43, 44). On September 27, 1821, for instance, he made three studies of the sky and the light on the trees under it, at 10 a.m., noon, and 4 p.m. (figs. 5–7). Such exercises were essential to the construction of his large exhibition pictures, though he is not known to have transcribed any of them directly onto his canvases.

For a British artist to gain recognition in the early years of the nineteenth century he had

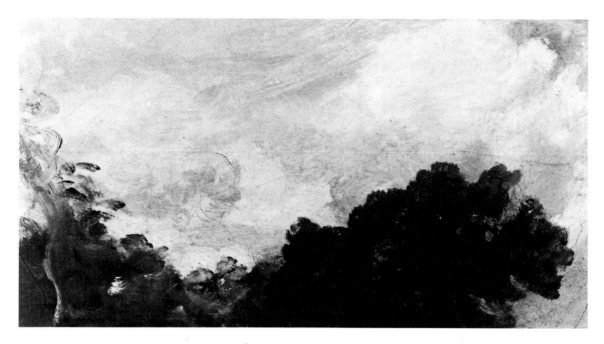

5. *Study of Clouds and Trees*. Inscribed: *Sept͏ʳ 27ᵗʰ 1821 — 10 morning, fine morning after Rainey night.* Oil on paper laid on board, 6½ x 12¼ in. New Haven, Yale Center for British Art, Paul Mellon Collection

to attract attention at the annual summer exhibition of the Royal Academy. The quiet, unemphatic naturalism of such paintings by Constable as *Flatford Lock and Mill* (No. 9) gained them a place in the selection, but they were too modest in size and too unpretentious in effect to stand out on those crowded walls. Discouraged by his lack of progress in public esteem, Constable wrote to Maria Bicknell in 1814 of his "propensity to escape from notice," which caused her to rebuke him vigorously: "I must have you known, and then to be admired will be the natural consequence." After his marriage in 1816 Constable was fully ambitious to be known. He was no longer able to paint his more important canvases in the open and he needed to present his ideas on a large enough scale to be noticed. He achieved this through the series of six-foot paintings of the scenery of the Stour that he exhibited from 1819 onward, beginning with *The White Horse* (Frick Collection, New York) and continuing through *The Hay Wain* (National Gallery, London) and *View on the Stour near Dedham* (see No. 19 and fig. 17).

When it appeared that Hampstead had not led to sufficient improvement in Maria's health, it was decided to try the sea air of Brighton, on the south coast. To begin with Constable was disgusted with the element of fashion — "Piccadilly...by the sea-side," as he described it — attracted by the Prince Regent's patronage. But as he grew accustomed to the new ambience he

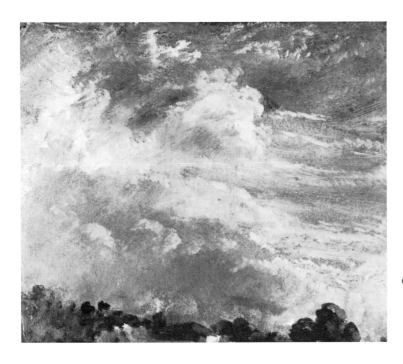

6. *Cloud Study over an Horizon of Trees.*
Inscribed: *Noon 27 Sep* *very bright*
after rain wind West. Oil on paper
laid on board, 9⅝ x 11½ in. London,
Royal Academy of Arts

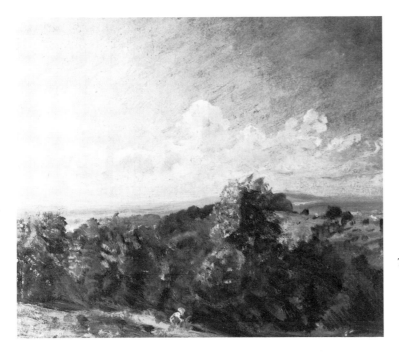

7. *Hampstead Heath Looking Towards*
Harrow. Inscribed: *4 afternoon 27 Sep*
1821 wood bank of Vale very [?warm]
& bright after rain. Oil on paper laid
on board, 9 x 11½ in. London,
Royal Academy of Arts

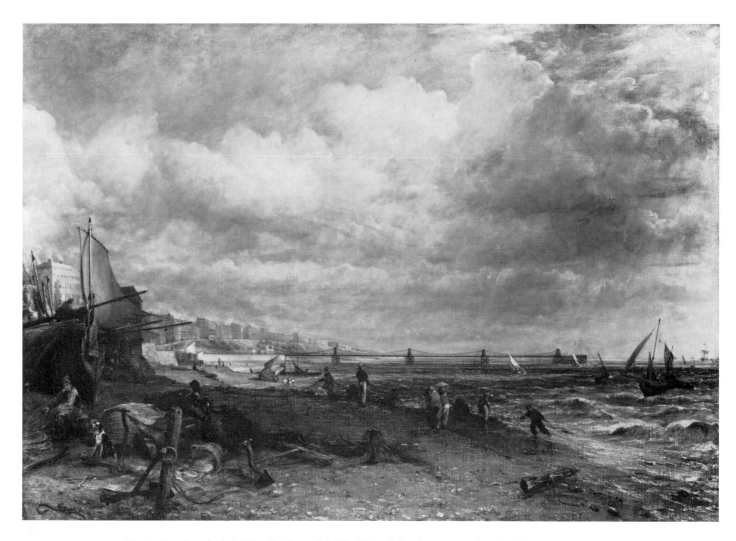

8. *Marine Parade and Chain Pier, Brighton*. Exhibited Royal Academy, 1827 (186). Oil on canvas, 50 x 72 in. London, Tate Gallery

found in it a fresh stimulus, providing different effects of atmosphere and color over the sea and a bustle of shipping which reminded him of the traffic on the Stour. He made only one ambitious painting of the place, the *Marine Parade and Chain Pier, Brighton* (fig. 8), which illustrates the central focus of the town and beach life. But the copious oil sketches he made on the shore and inland show by their variety and their sensitivity to evanescent effect that he had overcome his first, harsh opinion (Nos. 47–52).

The Constables persevered with visits to Brighton for five years, but to no avail. Maria

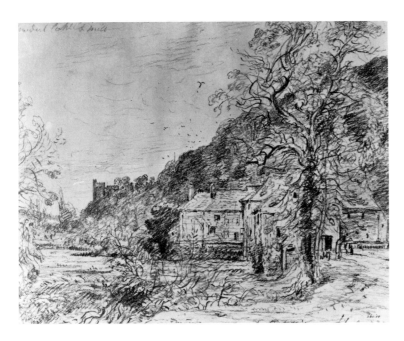

9. *Arundel Mill and Castle*. Dated: *July 9 1835*. Pencil, 8⅝ x 11 in. London, Victoria and Albert Museum

returned to Hampstead to die in November 1828, leaving her husband to care for their seven children. It was a blow from which his feelings never recovered. His art was already progressing from the serenity of its earlier phase to a more broken and accented style. This change, which partly reflects his personal anxieties, had been noted by his friends. Fisher wrote to him about the *Marine Parade and Chain Pier, Brighton* of 1827: "Mellow its ferocious beauties. Calm your own mind and your sea at the same time, & let in sunshine and serenity." His handling was much criticized for its lack of finish; now there were frequent complaints about his "whitewash" and "snow," descriptions applied to the broad, sharp accents of white by which he sought to convey his sense of the dewy freshness of nature. But it was a feature of Constable's development — a feature that renders the attempt to assign dates to undated works a hazardous one — that his style does not progress uniformly towards a rougher, more chaotic, more expressionistic method of handling.

In 1829 Constable paid his last visits to Fisher at Salisbury. *Hadleigh Castle* (No. 58), which he exhibited that spring, reveals clearly enough the turmoil and distress of his mind. As he wrote later, "every gleam of sunshine is blighted to me in the art at least. Can it therefore be wondered at that I paint continual storms?" Yet that summer he could make such sketches as *A View at Salisbury from John Fisher's House* (No. 35), which convey the tranquillity of his earlier and happier days.

In the last three years of Constable's life a new friendship brought a different type of

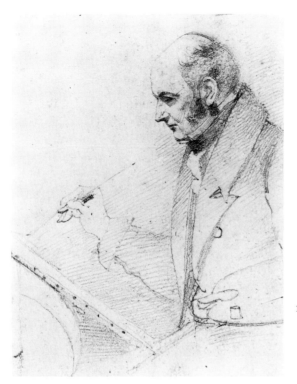

10. Daniel Maclise (1806–70), *Constable Painting*, ?1831. Pencil, 5⅞ x 4½ in. London, National Portrait Gallery

The drawing shows Constable when acting as Visitor to the life class at the Royal Academy.

landscape within his ken. The visits he paid to George Constable—the two men were not related—at Arundel, and to Lord Egremont at Petworth, revealed to him the downlands of Sussex, which he had not really explored when staying at Brighton. Here he again found the mills and castles that had already been a stimulus to his imagination; but they were set among wooded slopes and dramatic hills of a kind to which he had been unaccustomed since he had turned his back on the Lakes in 1806. These new sights aroused him to a burst of drawing in pencil (fig. 9) and watercolor. The only oils of this scenery he had time to complete before his death were the sketch and painting of Arundel Mill and Castle, both of which are shown here (Nos. 63, 64). As well as displaying his unimpaired capacity to assimilate fresh material, these works confirm that his style was entering a new phase. He had moved from the mood-ridden storms of *Hadleigh Castle* (No. 58) and *Old Sarum* (No. 36) to a warmer palette and more brilliantly expressive brushwork. When in its customary place in the Phillips Collection, Washington, D.C., *On the Stour* (No. 26) hangs without incongruity among some of the masterpieces of Impressionism. It is fair to assume that had he lived longer—and he was only sixty when he died in March 1837—Constable would have produced other rich examples of the

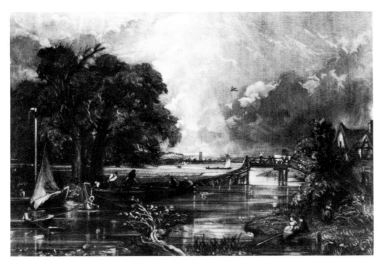

11. David Lucas (1802–81), after John Constable, *River Stour Co: of Suffolk*, from *English Landscape Scenery*, 1831. Mezzotint, 5⅝ x 8⅝ in. New York, The Metropolitan Museum of Art, Harris Brisbane Dick Fund, 1943 (43.75.19)

The mezzotint was engraved from *View on the Stour near Dedham* (No. 19).

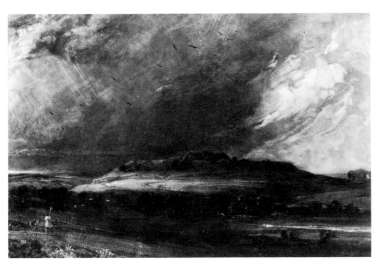

12. David Lucas, after John Constable, *Old Sarum*, from *English Landscape Scenery*, 1830. Mezzotint, 5½ x 8½ in. New York, The Metropolitan Museum of Art, Harris Brisbane Dick Fund, 1943 (43.75.14)

Engraved from the oil sketch (No. 36).

vein that he mined on a large scale only in the late and not fully completed *Stoke-by-Nayland* (No. 60).

For as well as exploring the use of a more heightened, less naturalistic color scale, Constable had entered a retrospective period in the last decade of his life (fig. 10). This is apparent in his lectures given between 1833 and 1836 to a number of learned societies, including the Royal Institution. The account that C. R. Leslie gives of the lectures in his biography of the artist shows that in them Constable presented a history of landscape painting which was wholly

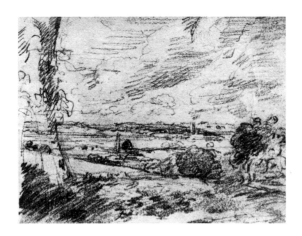 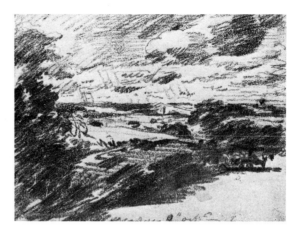

13. *Dedham Vale.* Pencil, 3⅛ x 4¼ in. London, Victoria and Albert Museum

14. *Dedham Vale.* Dated: *9ᵗʰ Octʳ.* Pencil, 3⅛ x 4¼ in. London, Victoria and Albert Museum

These are two pages from the small sketchbook Constable carried in his pocket while working in the fields near East Bergholt in 1814. They are drawn from approximately the viewpoint chosen for *The Stour Valley and Dedham Village* (No. 15), showing the scene under different conditions of light and shade.

original in its time and which is still valuable as a conspectus of the origins of landscape and the aims of its exponents. The immense effort Constable put into the preparation of his *English Landscape Scenery*, an enterprise which occupied him from 1829 till 1834, is also evidence of a retrospective frame of mind. To assemble a set of plates "characteristic of English scenery" he surveyed the whole contents of his studio before choosing the sketches, mainly oils, that he sent to David Lucas for translation into mezzotint. Although he did not attempt so comprehensive a system of classification as Turner had propounded in his *Liber Studiorum*, Constable did his best to achieve a balance among the types of landscape with which he had been most concerned.

In his choice of the subjects to be engraved the balance was not unexpectedly tilted strongly in favor of Suffolk. Constable excused this bias: "Perhaps the Author in his over-weening affection for these scenes may estimate them too highly, and may have dwelt too exclusively upon them; but interwoven as they are with his thoughts, it would have been difficult to have avoided doing so." Among the subjects near Flatford and East Bergholt chosen for *English Landscape Scenery* were *Dedham from Langham* (see No. 11) and *View on the Stour near Dedham* (No. 19, fig. 11). Local scenes from further afield are *The Glebe Farm* (see No. 25), *Helmingham Dell* (No. 62), and *Stoke-by-Nayland* (see No. 59). But the extent to which he diversified these views of his impressionable youth through the later enlargement of his interests is shown by

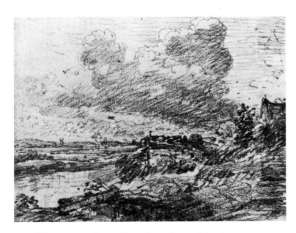

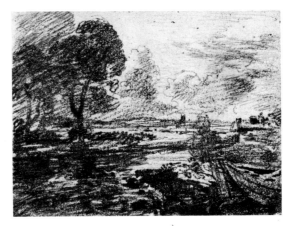

15. *View on the Stour*. Pencil, 3⅛ x 4¼ in. London, Victoria and Albert Museum

16. *View on the Stour*. Pencil, 3⅛ x 4¼ in. London, Victoria and Albert Museum

These drawings are on another two pages of the sketchbook of 1814 (see figs. 13 and 14). Constable combined elements from each drawing when settling the composition of No. 19 and fig. 17.

the number of other subjects here which are also associated with engravings for *English Landscape Scenery*. These include the Hampstead scene *Branch Hill Pond* (see Nos. 45, 46), the antiquities of *Old Sarum* (No. 36, fig. 12) and *Hadleigh Castle* (No. 58), and the central London theme of *The Opening of Waterloo Bridge* (No. 56).

This exhibition spans every variety of oil painting in which Constable indulged, and shows some aspect of almost every place to which he became attached. The most spontaneous are the oil sketches, often done on paper small enough to fit into the lid of his paintbox, made as records of fugitive appearances and often for the sheer pleasure of seeing and recollecting. Fisher compared such sketches with William Paley's sermons: "full of vigour and nature, fresh, original, warm from observation of nature, hasty, unpolished, untouched afterwards." There is, however, nothing hasty or unpolished about the larger canvases that Constable painted, for exhibition or sale, largely or wholly in the open air in front of the motif. It is probable that *Flatford Lock and Mill* (No. 9) and *The Stour Valley and Dedham Village* (No. 15) were painted out of doors. But the latter shows that in painting an open-air view Constable also relied on oil sketches such as Nos. 13 and 14, and on drawings (figs. 13, 14). These were not necessarily exactly transcribed onto the final canvas, but the fact of making them gave him a more acute sense of the forms and the atmosphere that he was aiming to incorporate.

When Constable wanted to paint Suffolk scenes after his marriage, it was no longer possible for him to spend the long summer days in the fields with the subject in front of him. Yet, as

he saw less and less of Suffolk, its image came to bulk more and more prominently in his mind. The necessity he was under of making a more conspicuous mark in the Royal Academy obliged him to paint those scenes on a larger scale. From 1819 to 1825 he exhibited his series of six-foot canvases, which showed scenes on the Stour within a short distance of Flatford. They were all painted in his London studio from the sketches and drawings he had done earlier in Suffolk, with skies made more actual by his observations in Hampstead. He overcame the problem of combining the freshness of his original sketches with the deliberation of composing on a monumental scale by painting an oil sketch of the size intended for the final exhibit. Two of these full-scale sketches are shown here, those for the *View on the Stour near Dedham* (No. 19) and *The Lock* (No. 21). To later ages these remarkable studies have sometimes seemed to embody more of Constable's ultimate intentions than the works he exhibited. But that is not the way Constable would have viewed it. The sketches he made in the fields and on the river bank were necessary preliminaries to these larger studies, and they in their turn were an essential step on the way to producing an exhibitable picture (figs. 15, 16; No. 19; fig. 17). In the full-size studies he could establish the main lines of the composition, combining viewpoints, introducing trees, barges, and other narrative details. These were all set down with that broad, strong handling, increasingly dependent on the palette knife, which we now admire; but neither Constable nor his contemporaries regarded this as the completed stage. As it was, his final versions were constantly criticized for their lack of finish and the absence in them of a delicate touch.

After exhibiting the series of six Stour scenes, Constable turned his attention to inland Suffolk. For *The Cornfield* (No. 23), his chief exhibit for 1826, he painted an oil sketch which is not quite half-size (No. 22). The juxtaposition here of these two works makes it possible to judge how far he amplified his final version through the addition of such enlivening elements as the boy drinking (see No. 6), the donkey and her foal, the flock of sheep herded by the dog, and—beyond the plow (see fig. 18) and the wheat standing ready for harvest—the distant view of a village dominated by a church tower.

Constable set out to paint more naturally than his predecessors in landscape painting. To do so he realized that it was necessary to develop a new way of seeing nature. As he wrote to Maria Bicknell in July 1812: "How much real delight I have had with the study of Landscape this summer. Either I am myself improved in 'the art of seeing Nature' (which Sir Joshua Reynolds calls painting) or Nature has unveiled her beauties to me with a less fastidious hand." So thoroughly did he achieve a revolution in seeing that he has communicated it to all his successors. We now take his vision so much for granted that we find it difficult to realize the full extent of the changes he brought about. He sought for truth to appearances, and truth is a difficult quality to define and analyze. For that reason the most revealing assessments of his work are to be found in the comments of his contemporaries who were familiar with the

17. *View on the Stour near Dedham*. Exhibited Royal Academy, 1822 (183). Oil on canvas, 51 x 74 in. San Marino, California, Henry E. Huntington Library and Art Gallery

No. 19 is the full-size oil sketch for this exhibited work.

traditions he sought to overturn and who were able to bring a fresh judgment to what he had accomplished. Géricault was astounded when he saw *The Hay Wain* in London in 1821. He communicated his enthusiasm to Delacroix, who never forgot Constable telling him that the green of his meadow was composed of a variety of different greens. The often-repeated story of how Delacroix made his style of painting in *The Massacre of Chios* lighter and more vibrant after seeing works by Constable records a real tribute paid by a great painter to a contemporary,

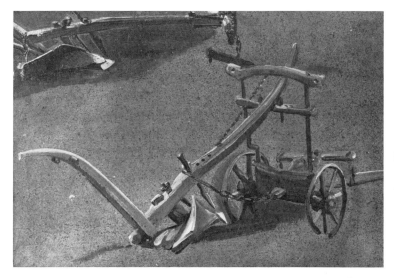

18. *Studies of Two Plows*. Dated: *2d Novr. 1814*. Oil on paper, 6¾ x 10¼ in. London, Victoria and Albert Museum

Constable used this sketch for the plow in *The Cornfield* (No. 23), painted in 1826, and again around 1835 for the plow in *Stoke-by-Nayland* (No. 60).

sincere because it was a practical one. Constable's first biographer, C. R. Leslie, saw him as "the most genuine painter of English landscape," a judgment anticipated by S. W. Reynolds, himself a talented landscape painter as well as engraver. Reynolds wanted to engrave *The Lock* at his own risk and wrote to Constable when he received it in his studio:

> It is no doubt the best of your works — true to nature, seen and arranged with a professor's taste and judgment. The execution shows in every part a hand of experience: masterly without rudeness, and complete without littleness. The colouring is sweet, fresh, and healthy; bright not gaudy, but deep and clear. Take it for all in all, since the days of Gainsborough and Wilson, no landscape has been painted with so much truth and originality, so much art, so little artifice.

Truth, originality, art without artifice: these were the very qualities that Constable had resolved to master. He had difficulty enough in convincing the collectors of his day that these were the staples of his art, but he had sufficient self-confidence and tenacity to follow his path with intense determination, and ultimate success. As he himself wrote of the landscape painter Richard Wilson: "He showed the world what existed in nature, but which it had never seen before."

CATALOGUE

I. THE CONSTABLE COUNTRY

I should paint my own places best — Painting is but another word for feeling. I associate my "careless boyhood" to all that lies on the banks of the Stour. They made me a painter (& I am grateful).

—Constable writing to John Fisher,
October 23, 1821 (JCC VI, p. 78)

In the coach yesterday coming from Suffolk were two gentlemen and myself, all strangers to each other. In passing through the valley about Dedham, one of them remarked to me — on my saying it was beautiful — "Yes Sir — this is Constable's country!" I then told him who I was lest he should spoil it.

—Constable writing to David Lucas,
November 14, 1832 (JCC IV, p. 387)

1. A Road near Dedham

New Haven, Yale Center for British Art, Paul Mellon Collection (B1981.25.130).
?1802. Oil on canvas, 13⅛ x 16⅜ in. (33.5 x 41.5 cm.).
COLL. Skirwith Abbey; H. E. M. Benn; Horace Buttery, 1962; Mr. and Mrs. Paul Mellon, 1963; given by them, 1981.
LIT. H.18; Richmond, 1963 (88); Washington, 1969 (2).

The view is from a road leading from East Bergholt to Flatford, looking south over the Stour towards the tower of Dedham church. The tower is a prominent vertical feature in this flat landscape and frequently occurs in Constable's paintings of Dedham Vale (for instance, Nos. 15, 17).

By 1802, after three years of study in London, Constable had become disillusioned with his progress. He felt that, like his fellow students, he had fallen into the habit of copying other artists' pictures instead of establishing a style of his own. He accordingly resolved to spend the summer in East Bergholt, avoiding social life and devoting himself to making "laborious studies from nature." In the letter of May 29, 1802, to his old sketching companion John Dunthorne senior in which he announced this plan, he added, "There is room enough for a natural painture" (presumably meaning "painter"; JCC II, p. 32).

By putting his resolve into effect Constable embarked upon the practice of sketching in oils in the open air and on the searching observation of nature that was to form the basis of his originality as an artist. There are three paintings in the Victoria and Albert Museum (R.36–38) which bear dates in the summer and autumn of 1802, and which show with what determination he sought to discover the principles of naturalism. Executed in the same technique as those works, on canvas of the same size and texture, this study was no doubt also painted in 1802.

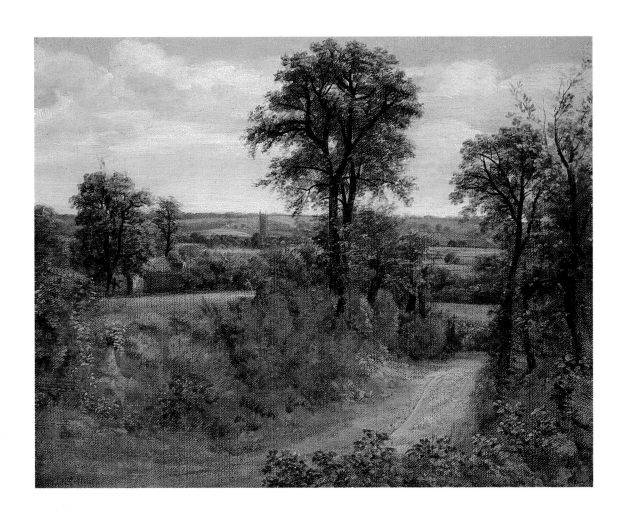

2. A View on the Stour

Philadelphia, The John G. Johnson Collection (J.857).
1810. Oil on paper laid on canvas, 10½ x 10½ in. (26.7 x 26.7 cm.).
Inscribed by the artist with the brush in the upper right corner: *27. Sep.* *1810.* A label on the back is signed:
Ella N. Constable (the artist's granddaughter). The canvas has been extended at the left and along the bottom
by the amount originally turned round the stretcher.
COLL. Isabel Constable; Ella N. Constable; E. Colquhoun; his sale, Christie's, May 28, 1891 (118); Colnaghi, 1891;
French Gallery, 1891; John G. Johnson, 1891.
LIT. H.109; Charles Rhyne, "Fresh Light on John Constable," *Apollo,* LXXXVII, 1968, fig. 1, p. 230 n. 21;
Tate, 1976 (92).

The view appears to be from the left bank of the Stour looking upstream towards Flatford Lock, with the towpath on the further bank.

During the years 1803–08 Constable expended his energies in a variety of directions. He painted an altarpiece and a number of portraits of local farmers. In 1806 he paid a long visit to the Lake District, where he made many watercolors and drawings on which he based the oil paintings he exhibited in 1807–09. But from about 1808 he concentrated on oil sketching in the open air at East Bergholt and Flatford, and spent less time on figure compositions or in traveling elsewhere. The full emergence of his brilliantly novel naturalism, swiftly executed and accurately observed in color and detail, dates from this period. The present sketch is one of the earliest dated examples of his maturity.

To accommodate more of the scene in front of him, Constable has enlarged his canvas by unfolding the turnovers at the left and bottom of the stretcher. He has carried his paint surface over to these new areas, though the ground of the canvas is different. This practice of enlarging the paint surface is one to which Constable frequently resorted in his later years, especially when planning large compositions in his studio; No. 21 is a case in point.

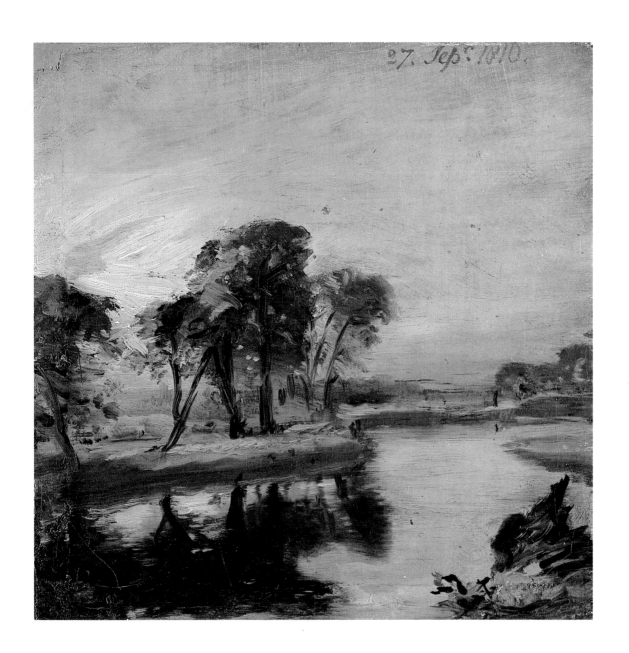

3. A View Towards East Bergholt Rectory

Philadelphia, The John G. Johnson Collection (J.856).
1810. Oil on canvas laid on panel, 6 x 9⅝ in. (15.3 x 24.5 cm.).
Inscribed by the artist with the brush along the right edge: *30 Sep! 1810 E. Bergholt Common.*
COLL. ?John Wilson; John G. Johnson, 1914.
LIT. H.110; Boston, 1946 (123); Tate, 1976 (93).

This has been identified by Charles Rhyne as one of a number of sketches that Constable made of the rectory at East Bergholt from the vicinity of his father's house. The scene had poignant associations for him. In 1809 he had fallen in love with Maria Bicknell, when she was staying with her maternal grandfather Dr. Durand Rhudde, rector of East Bergholt. The Bicknell family's fear of antagonizing Dr. Rhudde, who was a man of means and who objected to the match with an unsuccessful artist, delayed John and Maria's wedding till 1816. Constable wrote to Maria from East Bergholt on September 18, 1814:

> I believe we can do nothing worse than indulge in an useless sensibility — but I can hardly
> tell you what I feel at the sight from the window where I am now writing of the fields
> in which we have so often walked. A beautiful calm autumnal setting sun is glowing upon
> the gardens of the Rectory and on adjacent fields where some of the happiest hours of
> my life were passed. (JCC II, p. 132)

The sketch is of those fields where he had walked with Maria, though it is a morning and not an evening sun in which the rectory is glowing.

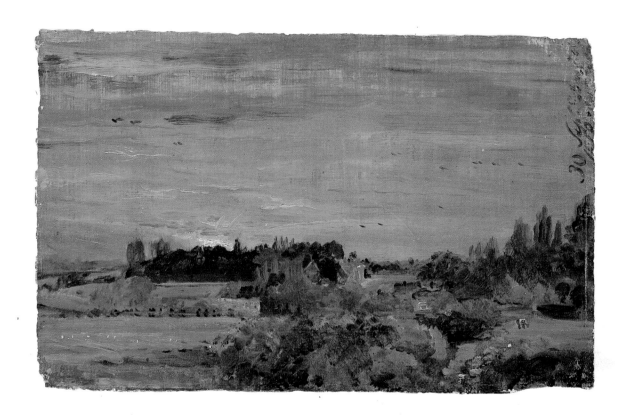

4. *A Cart on a Lane at Flatford*

London, Victoria and Albert Museum (326-1888).
1811. Oil on paper laid on canvas, 6 x 8½ in. (15.2 x 21.6 cm.).
A label on the stretcher is inscribed in ink: *17 May, 1811 L.B.C.* (Lionel Bicknell Constable, the artist's youngest son).
COLL. Lionel Bicknell Constable; Isabel Constable; given by her, 1888.
LIT. R.100; H.126

The view is from a lane leading to Flatford, looking south over the river Stour. Constable made another, slightly larger, oil sketch of the scene from virtually the same viewpoint but with different staffage, omitting the cart and introducing a man riding a donkey, a standing woman, and a seated man (R.329).

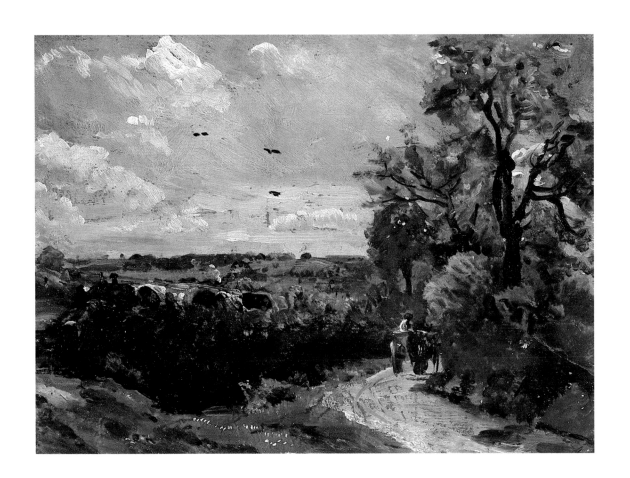

5. *Flatford Lock*

London, Royal Academy of Arts.
Ca. 1810–12. Oil on paper laid on board, 6⅝ x 9 in. (16.8 x 22.9 cm.).
COLL. Isabel Constable; given by her, 1888.
LIT. H.120; Tate, 1976 (97).

Flatford Lock, seen on the right of this sketch, is marked by a number of crossbeams attached to the upright posts (cf. No. 9); Constable sometimes omitted these crossbeams for pictorial effect when painting large compositions based on the lock, such as Nos. 21 and 24. Flatford Old Bridge and Bridge Cottage are in the central distance; the artist had the trees on the right of Nos. 7 and 9 behind him.

This sketch appears to have been painted about 1810–12. A sketch by John Dunthorne senior of the same scene, made in October 1814, is in the Colchester and Essex Museum (Tate, 1976 [339]).

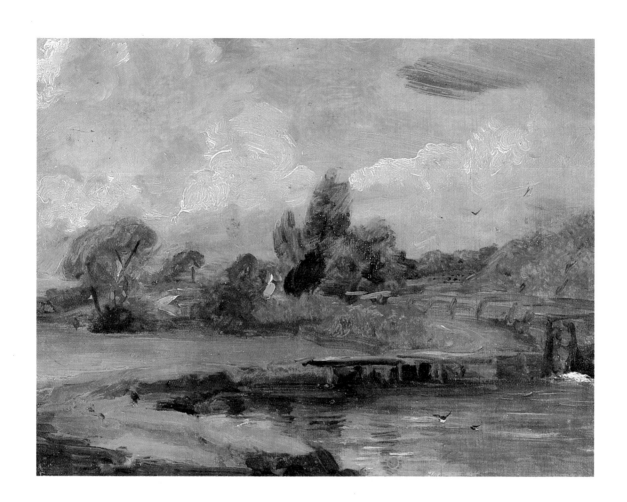

6. A Lane near Flatford

London, Tate Gallery (1821).
Ca. 1810–11. Oil on paper laid on canvas, 8 x 12 in. (20.3 x 30.5 cm.).
COLL. Henry Vaughan; bequeathed by him to the National Gallery, 1900; transferred, 1951.
LIT. P.10; H.144.

When painting *The Cornfield* (No. 23) for exhibition in 1826, Constable made use of the left-hand side of this earlier sketch (dating probably from about 1810–11), especially for the figure of the boy slaking his thirst from the stream. This has given rise to the supposition that the lane here is the one seen in *The Cornfield*, that is, Fen Lane, leading from East Bergholt to Dedham.

The sketch includes another figure, that of a girl with a blue shawl standing by the hedge in the right foreground.

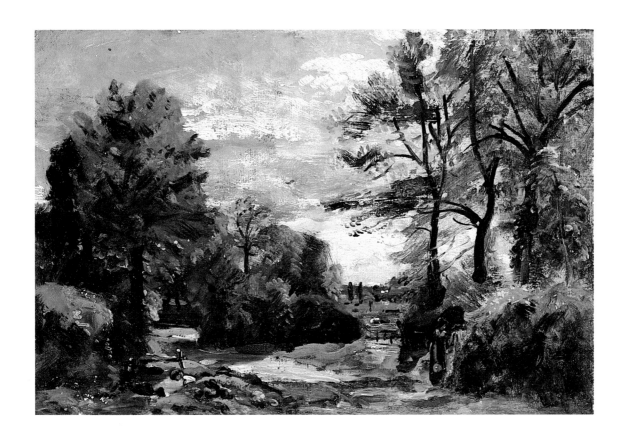

7. Flatford Mill from the Lock

Private collection.
Ca. 1810. Oil on canvas laid on board, 6 x 8¼ in. (15.2 x 21 cm.).
COLL. Isabel Constable; given by her to R. A. Thompson; by descent to his great-niece, Mrs. Bell Duckett; her sale, Morrison, McChlery & Co., Glasgow, March 18, 1960 (100); Agnew, 1960; private collection; by descent to the present owner.
LIT. H.115; Tate, 1976 (96).

This is one of a group of oil sketches made from a viewpoint close to the downstream gate of Flatford Lock, looking towards the tall poplars in the middle distance, with Flatford Mill on the left. One of these sketches, now in the Huntington Library and Art Gallery, is indistinctly dated, probably to 1810, and this is of the same period. Constable based his Royal Academy exhibit of 1812 (No. 9) on this group of studies.

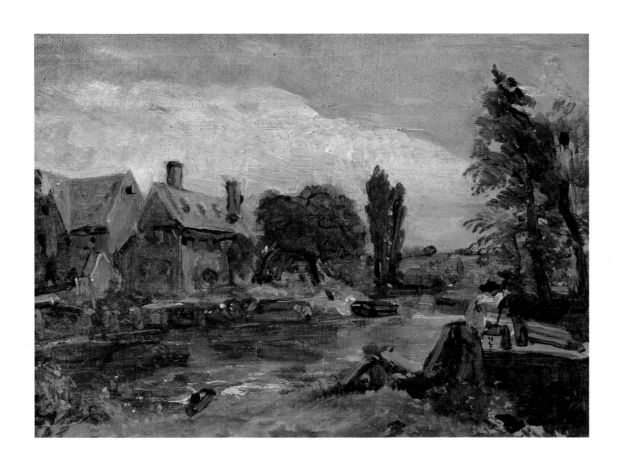

8. *A Lane in Suffolk*

New Haven, Yale Center for British Art, Paul Mellon Collection (B1981.25.142).
Ca. 1810. Oil on paper laid on canvas, 8¾ x 7¾ in. (22 x 19.5 cm.).
COLL. Mr. and Mrs. Paul Mellon; given by them, 1981.

This previously unpublished sketch appears to have been made about 1810. Constable seems here to be studying the morning effects that he later described in a text written for the plate *Summer Morning* in *English Landscape Scenery* (see No. 11). Contrasting them with the tones of evening, he wrote:

> The dews and moisture which the earth has imbibed during the night cause a greater depth and coolness in the shadows of the Morning; also, from the same cause, the lights are at that time more silvery and sparkling; the lights and shadows of Evening are of a more saffron or ruddy hue, vegetation being parched during the day from the drought and heat. (JCD, p. 17)

9. Flatford Lock and Mill

Washington, D.C., Corcoran Gallery of Art, anonymous loan.
1812. Oil on canvas, 26 x 36½ in. (66 x 92.7 cm.).
EXH. Royal Academy, 1812 (9).
COLL. R. Newsham; H. McConnell; Brooks; Sen. W. A. Clark; his sale, American Art Association,
January 12, 1926 (99); private collection; by descent to the present owner.
LIT. H.124.

This painting, lost to sight for some fifty years and only recently rediscovered, represents the culmination of the process of sketching at Flatford Mill that Constable had carried on assiduously around 1810–11 (No. 7 is one of four known oil sketches that he made from this viewpoint and that entered into the final work). It was the most impressive example, up to that date, of the application of his own type of naturalism to the scenery of the banks of the Stour.

After the painting had been accepted for hanging at the Royal Academy exhibition of 1812, Constable met the president, Benjamin West, who told him how much he approved of it. Reporting the meeting in his letter of April 24 to Maria Bicknell, Constable wrote: "I wished to know if he considered that mode of study as laying the foundation of real excellence. 'Sir' (said he) 'I consider that you have attained it'" (JCC II, p. 65).

10. *A Hayfield near East Bergholt at Sunset*

London, Victoria and Albert Museum (121-1888).
1812. Oil on paper laid on canvas, 6¼ x 12½ in. (16 x 31.8 cm.).
Inscribed by the artist with the brush in the lower right corner: *July 4 1812.*
COLL. Isabel Constable; given by her, 1888.
LIT. R.115; H.151.

The scene is of a hayfield on the slopes above Dedham Vale, close to East Bergholt where Constable spent the summer of 1812. His courtship of Maria Bicknell had encountered the opposition of her family, especially that of her grandfather Dr. Rhudde, rector of the village, and he lived the life of a recluse, occupying his time sketching in the fields. He wrote to Maria that he was proud of some of the sketches he had made and that he was "improved in 'the art of seeing Nature'" (JCC II, p. 81). He was not, however, making many of his studies in the middle of the "very hot bright days" (JCC II, p. 80), since he had almost put out his eyes by doing so in the previous year. This evening study shows that he was working later in the day in consequence.

11. Dedham from Langham

Oxford, Ashmolean Museum (A.399).
1812. Oil on canvas, 7½ x 12⅝ in. (19 x 32 cm.).
Inscribed by the artist with the brush in the lower left corner: *13 July 1812*.
COLL. Rev. W. Fothergill Robinson; bequeathed by him, 1929.
LIT. H.155; Tate, 1976 (112).

The view is from a ridge at Langham, on the other side of the river Stour from East Bergholt, looking down Dedham Vale towards the sea, with the tower of Dedham church prominent in the distance. Constable made a number of oil sketches and drawings from the same viewpoint and had the mezzotint *Summer Morning* engraved from an oil sketch very similar to this one (Victoria and Albert Museum, R.332). In the accompanying text he wrote that "the elegance of the tower of Dedham church is seen to much advantage, being opposed to a branch of the sea at Harwich, where this meandering river loses itself" (JCD, p. 17).

12. The Lock at Dedham

Philadelphia, The John G. Johnson Collection (J.863).
Ca. 1810–12. Oil on canvas, 6⅛ x 11¼ in. (15.5 x 28.6 cm.).
COLL. Leggatt; John G. Johnson, by 1914.
LIT. H.237; Tate, 1976 (138).

This sketch shows the lock gate at the Dedham village end of Dedham Lock; in No. 17, *Dedham Lock and Mill*, it is seen from the other direction. The sketch is not dated, but is presumably of about the same period as Nos. 7, 10, and 11.

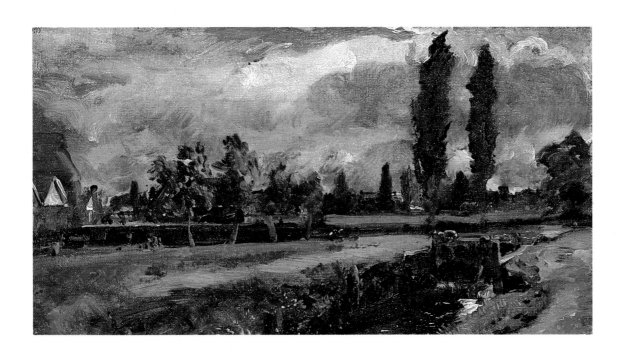

13. The Vale of Dedham

Leeds City Art Galleries (10/34).
1814. Oil on canvas, 15½ x 22 in. (39.4 x 55.9 cm.).
Inscribed by the artist with the brush in the lower right corner: *5 Sep^r 1814*.
COLL. J. N. Drysdale; Tooth; bought, 1934.
LIT. H.202; Ian Fleming-Williams, "A Runover Dungle and a Possible Date for 'Spring,'" *Burlington Magazine*,
CXIV, 1972, pp. 386–393; Tate, 1976 (127).

This is one of the preparatory studies for No. 15, *The Stour Valley and Dedham Village*. Painted in early September, it shows harvesters at work in the field on the left. The prominent hump in the foreground is a dunghill, in country parlance a "runover dungle," which the laborers are digging out.

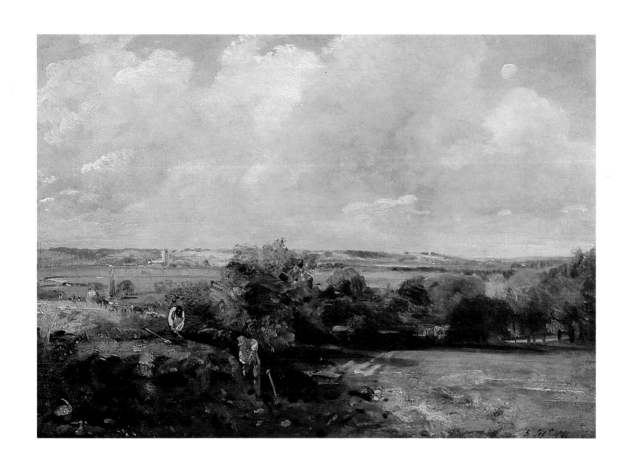

14. *Study of a Cart and Horses*

London, Victoria and Albert Museum (332-1888).
1814. Oil on paper, 6½ x 9⅜ in. (16.5 x 23.8 cm.).
Inscribed on the back in ink with the monogram: *JC*.
COLL. Isabel Constable; given by her, 1888.
LIT. R.135; H.204; Chicago/New York, 1946–47 (19).

This is one of the considerable number of studies that Constable made for No. 15. A companion study of the same cart, also in the Victoria and Albert Museum (R.134), is dated October 24, 1814, and this, which was used with variations in the finished picture, was no doubt made at about the same time.

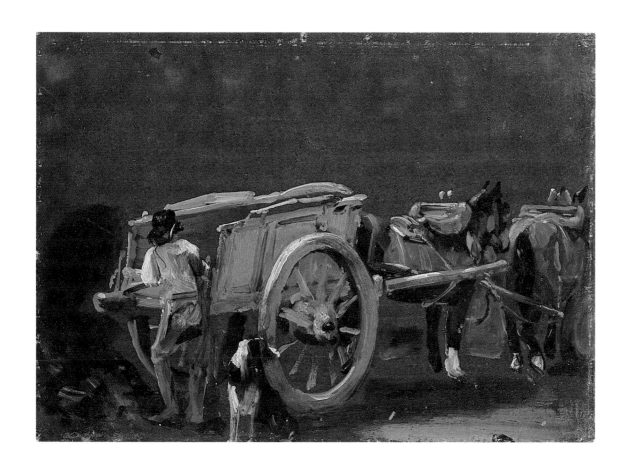

15. The Stour Valley and Dedham Village

Boston, Museum of Fine Arts, William W. Warren Fund, 1948 (48.226).
1814. Oil on canvas, 21¾ x 30¾ in. (55.3 x 78.1 cm.).
EXH. Probably Royal Academy, 1815 (20).
COLL. Commissioned by Thomas Fitzhugh as a wedding present for his bride, 1814; James McLean; by descent to his daughter, Mrs. Alice T. McLean; John Mitchell, 1948; bought, 1948.
LIT. H.207; Ian Fleming-Williams, "A Runover Dungle and a Possible Date for 'Spring,'" *Burlington Magazine*, CXIV, 1972, pp. 386–393; Tate, 1976 (133).

To mark his marriage to Philadelphia Godfrey, daughter of Peter Godfrey, lord of the manor of East Bergholt, this painting was commissioned by her future husband, Thomas Fitzhugh, so that his wife could be reminded in London of a familiar scene of her childhood. It shows the view of Dedham Vale from just outside the grounds of Old Hall, the Godfrey estate, and gives a panorama of the valley from that spot. The Stour is seen meandering in the valley basin, Dedham village is to the right of the center, and Langham, the viewpoint for No. 11, is on the ridge at the extreme right. Manure from the heap in the foreground is being loaded onto the cart for spreading in the fields.

Constable took great pains over painting the picture, working out of doors all day for most of September and October 1814. In that period he made nine drawings in a small sketchbook (see figs. 13, 14), now in the Victoria and Albert Museum, an oil sketch (No. 13), and two sketches of the cart and horses, one of which is No. 14. Not all this preparatory material was directly used in the painting but all helped in the full comprehension of the scene which makes this one of Constable's most natural renderings of his native landscape. It seems probable that it too was painted, in large part at least, in the open air in front of the motif.

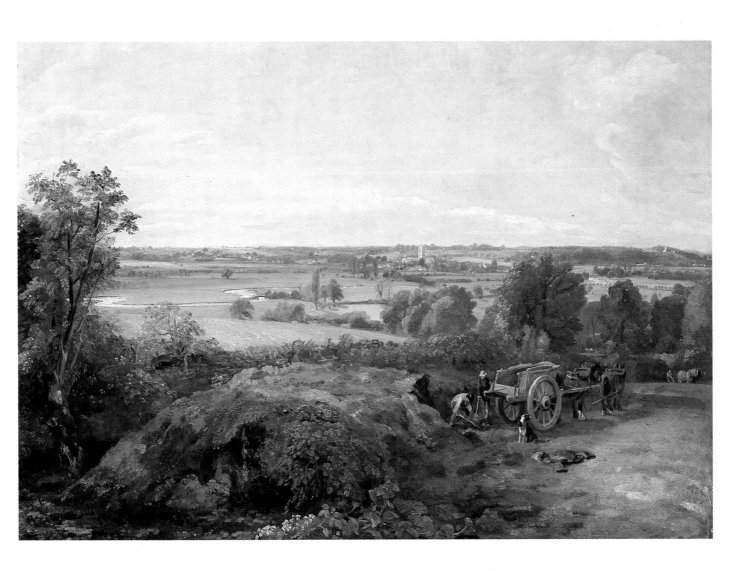

16. Willy Lott's House

Ipswich Museums and Galleries.
1816. Oil on paper laid on canvas, 7¼ x 8⅞ in. (18.4 x 22.5 cm.).
Inscribed on the back: *J. Constable — 29 July 1816*.
COLL. C. R. Leslie; his sale, Foster's, April 25, 1860 (90); Thomas Churchyard, 1860; S. Herman de Zoete; his sale, Christie's, May 8, 1885 (159); McLean, 1885; B. W. Leader; his widow, 1923; her sale, Christie's, April 8, 1927 (34); Blaker, 1927; Christie's, February 15, 1929 (57); bought, 1929.
LIT. H.221; Tate, 1976 (144).

This sketch of Willy Lott's house at Flatford was probably used by Constable as part of the preparatory material for *The Hay Wain* of 1821 (National Gallery, London). The house is also seen in *The Valley Farm* (Tate Gallery, London). A somewhat similar view (Ipswich Museums and Galleries), sketched from a position further to the right and showing more of the millstream flowing towards the main branch of the Stour, was one of the subjects mezzotinted by David Lucas for *England Landscape Scenery*, under the title *Mill Stream*.

Willy Lott lived in this farmhouse for eighty years and spent only four nights out of it during the course of his life. To Constable, therefore, he typified Suffolk tenacity and attachment to home.

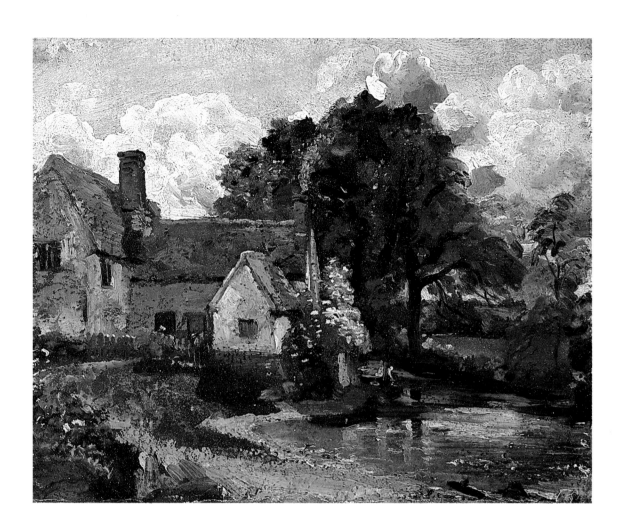

17. Dedham Lock and Mill

Manchester, N.H., The Currier Gallery of Art (1949.8).
Ca. 1820. Oil on canvas, 21½ x 30½ in. (54.6 x 77.5 cm.).
Signed lower right: *John Constable London.*
COLL. The Constable family; Miss Spedding, by 1841; by descent; Agnew, 1948; Knoedler, 1948; bought, 1949.
LIT. H.275.

Dedham Mill was, like Flatford Mill, owned and worked by John Constable's father. It is seen here from the Suffolk bank of the Stour looking over the lock towards Dedham church (Nos. 12 and 20 show the lock from the other end). After 1817 Constable was rarely in Suffolk long enough for painting or sketching in oils. Suffolk subjects, however, continued to bulk large in his output; they were usually painted in his London studio from sketches or drawings done earlier. This composition is derived from an oil sketch in the Victoria and Albert Museum (R.113) and a drawing, probably of 1817, in the Huntington Library and Art Gallery.

Constable may have exhibited a version of the finished composition at the Royal Academy in 1818, sending it on to the British Institution in 1819. If No. 17 could be identified with that exhibit, it would therefore have been painted in 1818. But C. R. Leslie, Constable's biographer, writing on January 19, 1841, to Maria Louisa Constable about the painting — then in Miss Spedding's possession — says that it was painted in 1820. That is the date inscribed by the artist with his signature on another version (Victoria and Albert Museum, R.184). In the latter the rope from the bollard in the right foreground is attached to the grazing horse rather than to the sailing barge as here. Another version in a private collection lacks the sailing barge on the left, as does an unfinished version or compositional sketch in the Tate Gallery (P.17).

Constable reverted to the theme in the 1830s, making a tempestuous, Claude-like, sepia drawing of the central section with the church tower seen above the horizontal crossbeam of the lock (Victoria and Albert Museum, R.410).

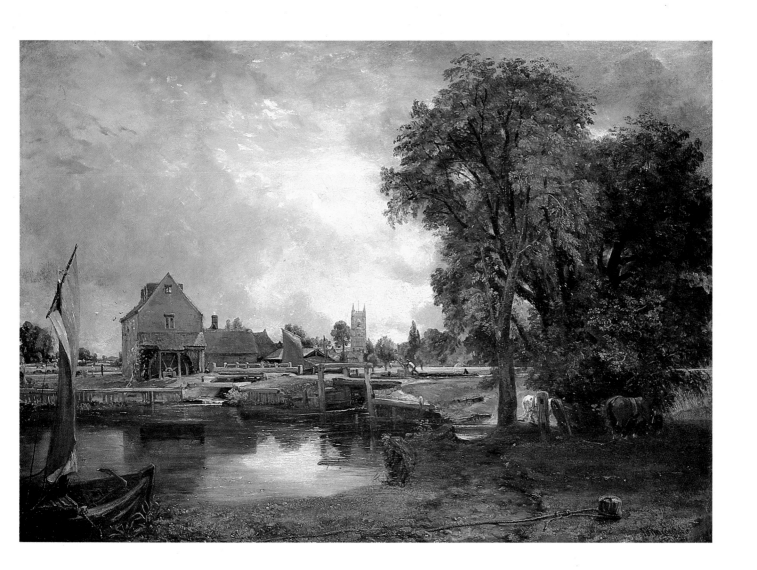

18. On the Stour

Edinburgh, National Gallery of Scotland (1219).
Ca. 1820. Oil on board, 8 x 9¼ in. (20.3 x 23.5 cm.).
COLL. Isabel Constable; her sale, Christie's, June 17, 1892 (217); Wigzell, 1892; George Salting; by descent to his daughter, Lady Binning; given by her, 1918.
LIT. Colin Thompson and Hugh Brigstocke, *National Gallery of Scotland: Shorter Catalogue*, Edinburgh, 1970, pp. 14–15; H.241.

The details in this sketch are not easy to make out. The central subject appears to be a barge, with its sail spread, that is being drawn on wheels by a team of horses — perhaps a barge being moved out of the dry dock for boat building and repair that Constable's father maintained just upstream from Flatford Mill. The bridge on the left, with a figure crossing it, may be Flatford Old Bridge.

The close stylistic affinity of this sketch with the small study for *The Hay Wain* at the Yale Center for British Art suggests that it too may be a studio composition rather than a study from nature, and that it may have been painted about 1820, perhaps with a larger composition in mind. On the back of the sketch is a study of a group of cows, one of a series that Constable had undertaken in the manner of the seventeenth-century Dutch painter Aelbert Cuyp. All are on board that he used again later for oil sketches painted on the reverse.

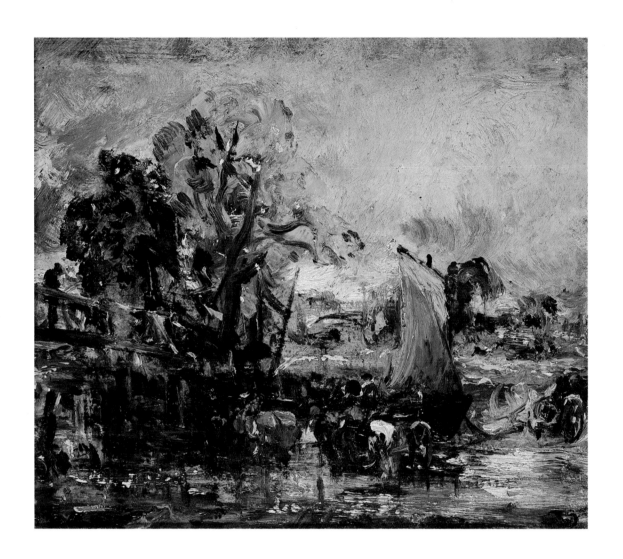

19. *View on the Stour near Dedham*

Egham, Royal Holloway College, University of London.
1821–22. Oil on canvas, 51 x 73 in. (129.5 x 185.4 cm.).
Engraved in mezzotint by David Lucas for *English Landscape Scenery* and published in the fourth part, 1831 (see fig. 11).
COLL. Perhaps the artist's sale, Foster's, May 15–16, 1838 (part lot 36); ?Morris, 1838; ?T. Woolner; ?his sale, Christie's, June 12, 1875 (134); Denison; J. M. Dunlop; his sale, Christie's, May 5, 1883 (61); Martin, 1883; Thomas Holloway, 1883, for Royal Holloway College (opened 1886).
LIT. Jeannie Chapel, *Victorian Taste: The Complete Catalogue of Paintings at the Royal Holloway College*, London, 1982, no. 5, pp. 72–74; H.329; New York/St. Louis/San Francisco, 1956–57 (22), pp. 30, 31; Tate, 1976 (201).

Constable based his main claim on the regard of posterity on six large, six-foot canvases of scenes along the banks of the river Stour: *The White Horse* (Frick Collection, New York), *Stratford Mill* (private collection), *The Hay Wain* (National Gallery, London), *View on the Stour near Dedham* (Huntington Library and Art Gallery, San Marino), *The Lock* (private collection; see No. 21), and *The Leaping Horse* (Royal Academy of Arts, London). They were painted and exhibited between 1819 and 1825. For most of them he made full-size sketches in his studio to establish the balance of the composition and the distribution of light and shade. These sketches were often carried to a considerable degree of completion, but were too summary in detail and too rough in texture to be regarded as exhibitable works in the artistic climate of the 1820s. The vogue for Constable's sketches grew only with the general taste for less highly finished work and rough textures that came into being with the rise of the Barbizon school.

View on the Stour near Dedham (fig. 17), for which this is the full-size study, was Constable's chief exhibit at the Royal Academy in 1822. It was bought by the French dealer John Arrowsmith and shown by him with *The Hay Wain* at the Paris Salon of 1824, when Constable's pictures created a furor. *View on the Stour near Dedham* then entered a French collection. Since Constable wanted to reproduce it in *English Landscape Scenery* and the final version was not available, he arranged for Lucas to make the mezzotint (fig. 11) from this sketch.

The scene is of the right bank of the river Stour just upstream from Flatford Lock. The viewpoint is beside the boat-building dock referred to under No. 18. Flatford Old Bridge and Bridge Cottage are on the extreme right, and the tower of Dedham church is seen in the central distance. The barges are of the type that took the flour ground by Constable's father at Dedham and Flatford Mills downstream for transfer to the coasters in which it was shipped to London; coal was carried on the return journey.

A major change Constable made in the final version of the composition was to add a second barge, which is being maneuvered in midstream. He painted out the man in a skiff on the left, replaced the cow on the bridge by a girl holding a child in her arms, and introduced other variations. He rendered the detail more clearly, remarking, "I have endeavoured to paint with more delicacy, but hardly anyone has seen it."

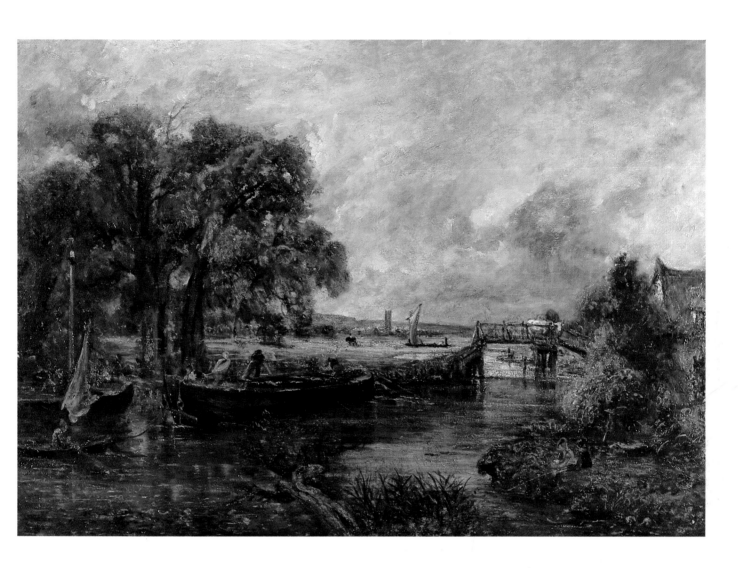

20. Dedham Lock

New Haven, Yale Center for British Art, Paul Mellon Collection (B1981.25.118).
Ca. 1820. Oil on canvas laid on board, 13¼ x 19⅝ in. (33.7 x 49.8 cm.).
COLL. Albert Hecht; by descent to his daughter, Mme Pontremoli; C. W. Harris, 1961; Leggatt, 1961; Mr. and Mrs.
Paul Mellon, 1961; given by them, 1981.
LIT. H.259; Richmond, 1963 (105); Washington, 1969 (30); P., p. 101.

Despite the reservations expressed by Hoozee and Parris, this is a brilliant and authentic sketch in which Constable is working out a composition known in two other studio studies, one at the Yale Center for British Art and the other in the Tate Gallery (P.24).

The view is of Dedham Lock and church seen, as in No. 12, from the end opposite to that chosen for No. 17. It appears from the group of studies that Constable was contemplating a painting of a barge approaching or leaving Dedham Lock, somewhat similar to the scene he placed at Flatford Lock (Nos. 21, 24). If this was his intention he is not known to have carried it out, and he may have abandoned it for the Flatford Lock composition. The sketch has the associative interest of having belonged to the noted Impressionist collector Albert Hecht. It must be one of the earliest genuine sketches by Constable that the Impressionists could have seen in a French collection.

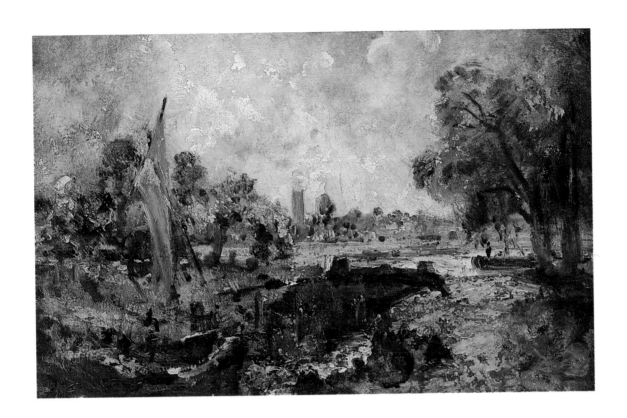

21. The Lock

Philadelphia Museum of Art, McFadden Collection (M'28-1-2).
Ca. 1823–24. Oil on canvas, 55¾ x 48 in. (141.7 x 122 cm.).
The canvas has been enlarged by the artist at the top and bottom to a total extent of about 10–12 in., and has been cut down on the right side. On the back is a study of a female head.
COLL. Ernest Gambart; his sale, Christie's, May 3–4, 1861 (294); E. A. Leatham, 1861; his sale, Christie's, May 18, 1901 (121); Vicars, 1901; Agnew, 1901; John H. McFadden, 1901; acquired, 1928.
LIT. H.404; Detroit/Philadelphia, 1968 (128).

This is the full-size sketch for the fifth of Constable's large Stour scenes. He had originally intended to exhibit the composition at the Royal Academy in 1823, but interrupted the Stour series with *Salisbury Cathedral from the Bishop's Grounds* (see Nos. 31, 34). The final version of *The Lock* was completed for exhibition in 1824 and, exceptionally for Constable, was sold on the opening day to a stranger, James Morrison, M.P. It has remained in the family of his descendants.

The fact that the canvas of this sketch has been cut on the right, and has been substantially increased in height, shows that Constable originally planned a horizontal composition, in line with the other large Stour scenes. However, he had converted it to a vertical format early in 1823, when he wrote about it to Fisher as an upright landscape.

Flatford Lock is seen here almost from the lower water level. The keeper is opening the shutter of the lock gates to enable the barge waiting in the basin to proceed on its journey downstream. X-ray photographs show that Constable originally included the crossbeams attached to the upright posts of the lock, which are seen in No. 5. For pictorial effect he removed them in this sketch and did not include them in the exhibited work.

This is the only known preliminary in oils to the upright version of the composition. Constable subsequently painted a horizontal variant, No. 24; the recorded drawings are all related to that version.

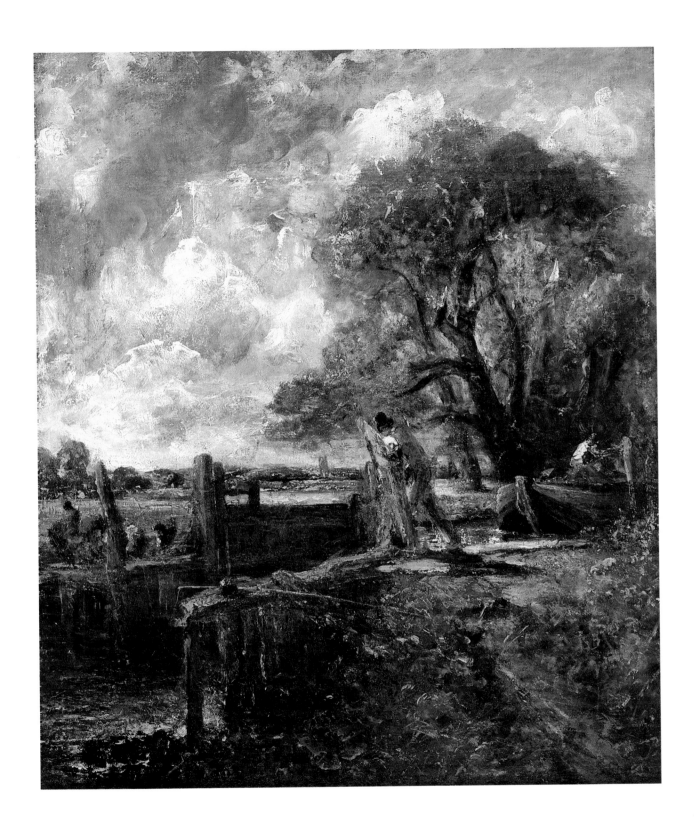

22. Study for *The Cornfield*

Birmingham Museums and Art Gallery, anonymous loan.
?Ca. 1826. Oil on canvas, 23½ x 19⅜ in. (59.7 x 49.2 cm.).
COLL. Probably Isabel Constable; her sale, Christie's, June 17, 1892 (244); Gooden, 1892; James Orrock;
private collection, 1895; by descent to the present owner.
LIT. H.466.

This sketch, slightly under half-size, for *The Cornfield* (No. 23) is generally taken to have been painted in the studio rather than in front of the motif. It lacks the figures, the animals, and the view of Higham village that Constable introduced into the exhibited version. In that version he also replaced the comparatively healthy tree in the left foreground by a dead specimen, derived from an early oil sketch (now in the Art Gallery of Ontario, Toronto).

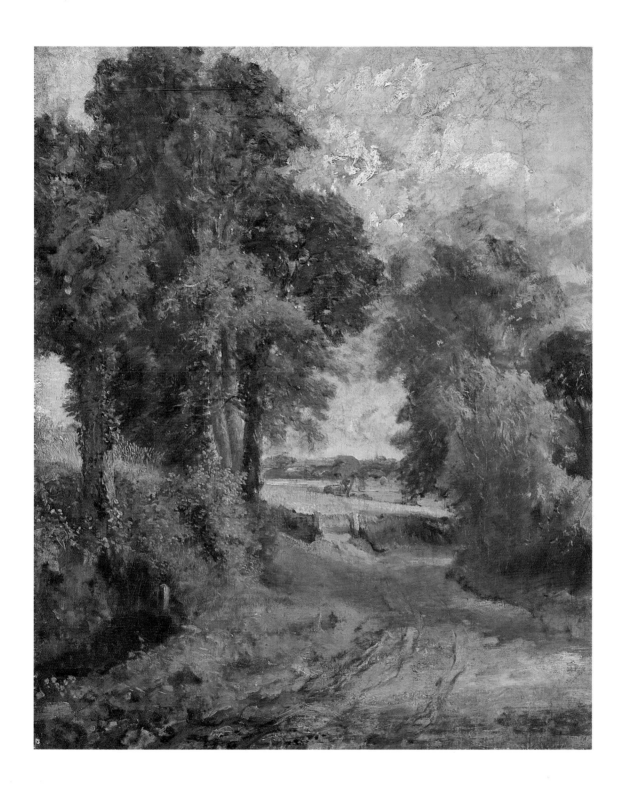

23. The Cornfield

London, National Gallery (130).
1826. Oil on canvas, 56¼ x 48 in. (143 x 122 cm.).
Signed and dated lower right: *John Constable. f. London. 1826.*
EXH. Royal Academy, 1826 (225); British Institution, 1827 (101); Paris Salon, 1827 (219).
COLL. Presented by a body of subscribers, under the chairmanship of Sir William Beechey,
after Constable's death, 1837.
LIT. Martin Davies, *National Gallery Catalogues: The British School,* 2nd ed., London, 1959, pp. 9–11; H.467;
Alastair Smart and Attfield Brooks, *Constable and His Country,* London, 1976, pp. 107–119; Tate, 1976 (242).

When he exhibited the painting for the second time, at the British Institution in 1827, Constable quoted with its title "Landscape: Noon" the lines by James Thomson:

A fresher gale
Begins to wave the woods and stir the stream,
Sweeping with shadowy gust the fields of corn.
(*The Seasons,* "Summer," ll.1654–1656, as printed in the catalogue)

The scene shows the lane from East Bergholt to the Vale of Dedham, called Fen Lane. It led to the New Fen Bridge over the Stour, and as a boy Constable had been in the habit of walking down it and across the bridge to school at Dedham. For pictorial effect he has introduced a distant view of Higham village and church at the end of the vista; in reality they are not visible from this point.

Constable planned the painting as a pendant to the vertical composition he had exhibited two years before, *The Lock* (see No. 21). Unlike the series of Stour scenes of which that is a member, this is an inland subject; but like them it was a scene very familiar to him from his childhood. He often referred to the picture as "The Drinking Boy," and this figure, taken from an earlier sketch (No. 6), may have recalled occasions when he slaked his own thirst from the wayside stream. He consulted the naturalist Henry Phillips about the plants that would be in flower in July, the month of the painting, and included cow parsley, bramble, water plantain, and butterburr.

No oil sketch or drawing made at the scene is known, but in addition to the medium-sized study (No. 22) there are a number of sketches for details. These include one for the dead tree (Art Gallery of Ontario, Toronto), and oil sketches in the Victoria and Albert Museum for the donkey and foal (R.287) and for the plow (fig. 18). Constable hoped to sell the painting "as it has certainly got a little more eye-salve than I usually condescend to give" (letter to John Fisher, April 8, 1826; JCC VI, p. 217). Though it was not sold in his lifetime, its "eye-salve" led to its choice by his friends for the national collection after his death.

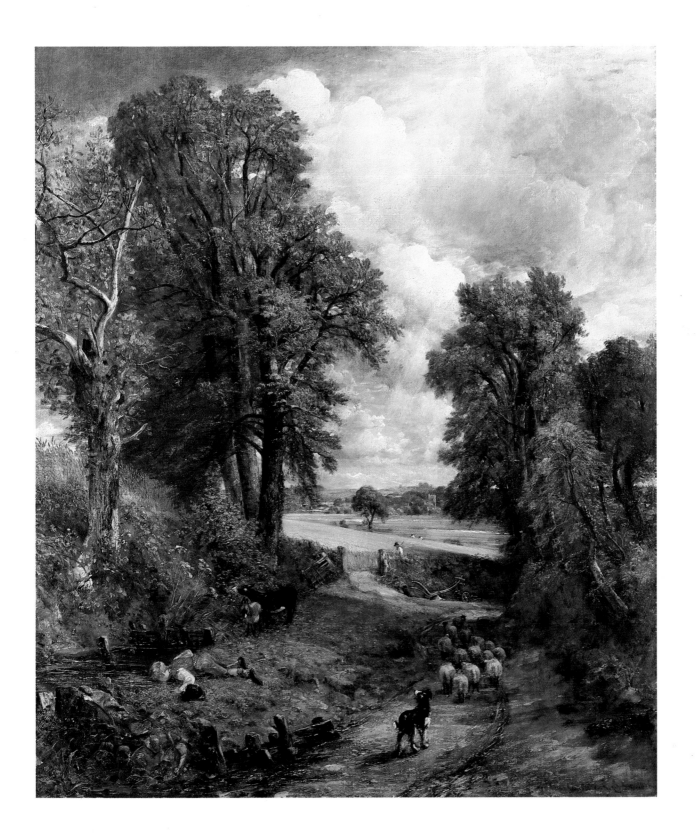

24. A Boat Passing a Lock

London, Royal Academy of Arts.
1826. Oil on canvas, 40 x 50 in. (101.6 x 127 cm.).
Signed and dated on the horizontal beam below the lock gate at the left: *John Constable. f. 1826.*
COLL. Painted for James Carpenter, 1826; taken back by the artist and presented by him to the Royal Academy as his Diploma work, 1829.
LIT. H.472; Tate, 1976 (262).

This picture is a later variant of *The Lock* (see No. 21), transformed into a horizontal composition. In changing the format Constable also varied the action: here a boat is seen waiting below the lock to enter the basin on its passage upstream. By extending the scene to the right Constable has brought Flatford Old Bridge and Bridge Cottage into view; these are prominent in *View on the Stour near Dedham* (see No. 19).

Constable received the commission to paint this picture from the bookseller James Carpenter in 1826, but had not delivered it two years later. Under the rules of the Royal Academy a newly appointed academician does not receive his diploma till he has given a work to the institution. On his election in February 1829 Constable decided that he wished this version of *The Lock* to represent him in the Diploma Gallery. Although *Helmingham Dell* (No. 62) was intended for Carpenter as a replacement, in the end Constable did not carry out his undertaking to paint Carpenter another picture of the same size, and the episode left the artist and his would-be patron with angry feelings about one another.

There is an unfinished version of, or sketch for, No. 24 in the National Gallery of Victoria, Melbourne, Australia, and drawings showing the composition in its horizontal form are in the Fitzwilliam Museum, Cambridge.

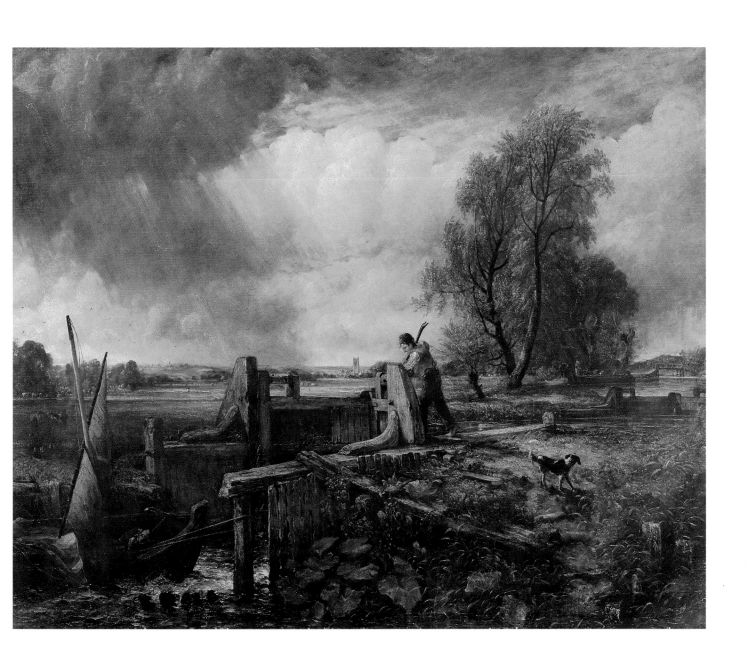

25. The Glebe Farm

London, Tate Gallery (1823).
Ca. 1830. Oil on canvas, 23½ x 30¼ in. (59.7 x 78.1 cm.).
COLL. Given by the artist to C. R. Leslie, ca. 1830; his sale, Foster's, April 25, 1860 (97); Hobson (or Holson), 1860;
Henry Vaughan, 1860; bequeathed by him to the National Gallery, 1900; transferred, 1919.
LIT. P.38; H.537.

Constable's acquaintance for twenty-seven years, the Reverend John Fisher, D.D., later bishop of Salisbury, was at one time rector of Langham, Essex (a favored viewpoint for Dedham Vale; see No. 11). Constable was introduced to him there in 1798 and became in a sense his protégé. It was to Dr. Fisher that he owed some of his most influential introductions and above all his close personal friendship with the older man's nephew and namesake, John Fisher, archdeacon of Berkshire. When the bishop died in 1825 Constable wanted to paint a picture as a memorial to him. He chose as his subject the Glebe Farm and church of Langham, where they had met (the farm takes its name from an ancient term denoting church property). The farmhouse in this painting is based upon an oil sketch of about 1810 (Victoria and Albert Museum, R.111); there is no known study for the church, which cannot in fact be seen from the viewpoint of the painting since it is over the brow of the hill.

Constable exhibited a first version of the composition at the British Institution in 1827; this is taken to be the painting now in the Detroit Institute of Arts. A larger version, also in the Tate Gallery (P.37), was mezzotinted by David Lucas for *English Landscape Scenery* in 1832. No. 25 differs from that composition by the addition of the tree in the left center foreground. The painting's unfinished state is accounted for by the entry in the catalogue of C. R. Leslie's sale in 1860, which records that:

> Mr. Leslie saw Constable at work on this picture, and told him he liked it so much he did not think it wanted another touch. Constable said, "Then take it away with you that I may not be tempted to touch it again." The same evening the picture was sent to Mr. Leslie as a present.

The episode, which seems to have occurred about 1830, is of interest in showing that Constable was aware that he was criticized for overworking his pictures and not letting well alone.

26. On the Stour

Washington, D.C., The Phillips Collection.
Ca. 1834. Oil on canvas, 24⅜ x 31⅛ in. (62 x 79 cm.).
COLL. "A niece of John Constable," ?Alicia Whalley; Sir Joseph Beecham; his sale, Christie's, May 3, 1917 (7); bought in by Freeman; Sir Thomas Beecham; sold by him, 1918; Scott and Fowles, 1925; Duncan Phillips, 1925.
LIT. H.562; Boston, 1946 (143).

Constable bought back *The White Horse* (Frick Collection, New York) from his friend John Fisher in 1829. Soon after he made an outline drawing repeating with variations the left side of its composition (British Museum, dated *Christmas Day 1829*). The effect was to make Willy Lott's house at Flatford the prominent feature on the right side of the revised composition; Constable also replaced the barge and tow horse in the earlier work by a man in a ferryboat, and altered the grouping of the trees. He made a number of versions of this revised composition, among which are a watercolor in the British Museum, an oil sketch in the Victoria and Albert Museum (R.403), the present work, and a slightly larger oil sketch in the Kennedy Memorial Gallery, Los Angeles. In most of them he made considerable changes in the architecture of Willy Lott's house and other variations in the staffage.

It seems that Constable had contemplated making from this sequence another Stour scene in a horizontal format to follow the series begun with *The White Horse* in 1819 and terminated by *The Leaping Horse* in 1825, with the theme of "A Farmhouse on the River Stour." If this was his intention he abandoned it in favor of the vertical composition *The Valley Farm* (Tate Gallery, London), exhibited at the Royal Academy in 1835, which shows the southwest corner of Willy Lott's house rather than the southeast side, seen here from further downstream.

The picture was probably painted about 1834 as part of this series of reworkings of a far earlier idea. It is a brilliant example of the final phase of Constable's style at its most balanced and mature. The warm tonality, flickering highlights, and dashing use of the palette knife are all characteristic of his latest manner.

II. COUNTRY HOUSES

Shee told me it was "only a picture of a house," and ought to have been put into the Architectural Room. I told him that it was "a picture of a summer morning, including a house."

> —Constable writing to Samuel Lane,
> May 14, 1833; the picture was *Englefield House, Berkshire*, exhibited that year at the Royal Academy, and his critic was the president of the Royal Academy,
> Sir Martin Archer Shee (JCC IV, p. 254)

27. *Wivenhoe Park, Essex*

Washington, D.C., National Gallery of Art, Widener Collection, 1942 (606).
1816. Oil on canvas, 22⅛ x 39⅞ in. (56.1 x 101.2 cm.).
The canvas has been extended by the artist by about 3 – 4 in. at the left and right sides.
EXH. Royal Academy, 1817 (85).
COLL. Painted for Maj.-Gen. F. Slater-Rebow, 1816; by descent until 1905; Nardus; P. A. B. Widener; bequeathed by him, 1942.
LIT. H.218; E. H. Gombrich, *Art and Illusion: A Study in the Psychology of Pictorial Representation*, The A. W. Mellon Lectures in the Fine Arts, 1956, National Gallery, Washington; Bollingen Series XXXV:5, New York, 1960, passim; Rosemary Feesey, *A History of Wivenhoe Park*, Colchester, 1963; H. Lester Cooke, *Painting Lessons from the Great Masters*, New York, 1967, p. 102.

This painting was commissioned by Major-General Francis Slater-Rebow, owner of Wivenhoe Park and Alresford Hall, near Colchester. Constable had painted a full-length portrait of the general's daughter in 1812 and remained on friendly terms with the family. The general knew of his long courtship of Maria Bicknell and of their eventual decision to get married in 1816; he gave Constable this commission to help with the wedding expenses. He also ordered a smaller landscape of the fishing lodge in the grounds of Alresford Hall, which is now in the National Gallery of Victoria, Melbourne, Australia.

A letter Constable wrote to Maria from Wivenhoe Park on August 30, 1816, shows that he painted this picture almost entirely in the open air in front of the scene: "I live in the park and Mrs. Rebow says I am very unsociable" (JCC II, p. 199). He also said that it had been difficult to include as wide a vista as the general wanted in the painting, which was to show both the grotto on the left and a deer house on the extreme right. It was to meet these wishes that Constable added the strips to his canvas at the right and left edges; the fishing boat crosses the seam on the right, and the foremost cow was added to cover the seam on the left. The general's daughter Mary Rebow is seen driving in a donkey cart towards the clump of trees at the extreme left.

The major landscaping of Wivenhoe Park, with the construction of the artificial lake, was undertaken in 1777. The house, much altered, is now part of the university of Essex.

In *Art and Illusion* Gombrich makes this painting a central feature of his analysis of the psychology of artistic perception.

28. Malvern Hall, Warwickshire

Williamstown, Mass., Sterling and Francine Clark Art Institute (683).
1821. Oil on canvas, 21¼ x 30¾ in. (54 x 78 cm.).
A label formerly on the back, which has not been preserved, is said to have been inscribed: *Malverne Hall, Warwickshire. The seat of R.[sic] G. Lewis, Esq^r 1821. This picture belongs to Magdalena Countess of Dysart.*; and *No. 5, Malverne Hall Warwickshire. John Constable.*
COLL. Painted for Magdalene, dowager countess of Dysart; by descent to her brother, Henry Greswolde Lewis, 1823; by descent to E. M. W. Lewis, 1829; by descent to his great-niece, Mrs. Florence H. N. Suckling, 1833; her sale, Sotheby's, July 23, 1924 (112); Knoedler, 1924; Robert Sterling Clark, 1926.
LIT. H.326; Tate, 1976 (202).

Although Constable disclaimed any capacity for getting on with the nobility, he formed a number of friendships among the more aristocratic families of his time. That with the Dysarts was especially long-standing. They sprang from the Tollemaches of Helmingham, about ten miles north of Ipswich, a family which had originated at Bentley near East Bergholt. The second wife of Lionel, fifth earl of Dysart, was Magdalene, the sister of Henry Greswolde Lewis, whose family mansion was Malvern Hall, Solihull, Warwickshire.

Constable stayed at Malvern Hall in 1809 and 1820. On the earlier visit he painted a picture of the house seen from over the lake (now in the Tate Gallery, London), which is one of the first examples of his serene naturalism at its most balanced. On the second visit Lewis, who had been restoring the facade, suggested that Constable might like to paint the house again, saying that it "would make a much better figure in Landscape than when you painted it last" (JCC IV, p. 64). The restoration consisted of replacing the architraves, stringcourses, keystones, and other ornaments which "that modern Goth" Sir John Soane had removed in a drastic remodeling of 1783. On this second visit Constable made a full-size sketch of the entrance front (now in the Yale Center for British Art). After his return to London he painted a pair of views of the house for his host's sister, the dowager countess of Dysart. This canvas, based on the sketch in the Yale Center, is one of that pair; the other (now in the National Museum of Havana) shows the house from over the lake and is a more elaborated version of the picture in London. A repetition of the present view, signed and dated 1821, which Constable probably exhibited at the Royal Academy in 1822 (219), has been in France at the Musée de Tessé, Le Mans, since 1863.

III. OSMINGTON AND GILLINGHAM, DORSET

[The] distant Dorsetshire hills made me long much to be at dear old Osmington, the remembrance of which must always be precious to you & me.

—Constable writing to his wife
from Gillingham, August 29, 1823
(JCC II, p. 284)

It is my wish to come to see you at Gillingham. I want to do something at that famous Mill, a mile or two off. You are in the midst of fine stuff.

—Constable writing to John Fisher,
May 9, 1823 (JCC VI, p. 116)

29. Weymouth Bay from the Downs
Above Osmington Mills

Boston, Museum of Fine Arts, Bequest of Mr. and Mrs. William Caleb Loring (30.731).
1816. Oil on canvas, 22 x 30¼ in. (55.9 x 76.9 cm.).
COLL. Probably the artist's sale, Foster's, May 15–16, 1838 (part lot 45); bought in; Capt. Charles Golding
Constable; his widow, Mrs. A. M. Constable; his sale, Christie's, July 11, 1887 (75); Agnew, 1887; W. H. Fuller,
1888; his sale, Chickering Hall, New York, February 25, 1898 (20); Mr. and Mrs. W. C. Loring, 1898; bequeathed
by them, 1930.
LIT. H.230; Boston, 1946 (127); Tate, 1976 (149).

Osmington is a small village about three miles east of Weymouth and just inland from the
fishing hamlet of Osmington Mills on the south coast. Constable owed his knowledge of it to
his closest friend John Fisher, who was vicar of Osmington among his many preferments.
Fisher married John and Maria Constable at St. Martin-in-the-Fields, London, on October 2,
1816, and invited them to spend part of their honeymoon with him and his wife at Osmington.

Their visit lasted about six weeks, and although Constable made numerous pencil draw-
ings of the coastal and inland scenery (see fig. 4), he painted few oil sketches. This view from
the cliffs south of Osmington village appears from its clearly expressed detail and accurate
topography to have been painted on the spot. Fisher was an amateur artist and provided the
materials and canvases that Constable needed. The scene comprises Osmington Bay on the
left, divided by the projecting Redcliff Point from Weymouth Bay, which lies beyond to the
right. Portland Island is seen in the distance on the left.

Although Constable never returned to Osmington, he based a number of later paintings
on the sketches and drawings he made on this visit, and always thought of the place with
affection.

30. Gillingham Mill

Cambridge, Fitzwilliam Museum (2291).
1824. Oil on canvas, 9¾ x 11⅞ in. (24.8 x 30.2 cm.).
The original stretcher is inscribed on the back in an unidentified hand: *London June 7th 1824 John Constable fecit*. The painting has been relined; the original canvas was inscribed on the back: *John Fisher 1824*, and in another hand: *J. Constable R.A. fecit* and *property of his son Osmond Fisher*.
COLL. Painted for Archdeacon John Fisher, 1824; by descent to his son, Rev. Osmond Fisher, 1832; bequeathed by him to the Fitzwilliam Museum subject to a life interest for his son, Rev. O. P. Fisher (d. 1937).
LIT. J. W. Goodison, *Fitzwilliam Museum, Cambridge: Catalogue of Paintings*: III. *British School*, Cambridge, 1977, pp. 45–47; H.407.

In 1819 John Fisher, already archdeacon of Berkshire, was made vicar of Gillingham, Dorset, in addition to his other livings. Constable paid Gillingham a short visit when staying with Fisher at Salisbury in 1820, and was greatly impressed by the picturesque appearance of Perne's, or Parham's, Mill. As he wrote: "the sound of water escaping from Mill dams...Willows, Old rotten Banks, slimy posts, & brickwork. I love such things—" (JCC VI, p. 77). They reminded him, too, of his childhood on the Stour.

In the summer of 1823 he stayed with Fisher for over two weeks at Gillingham, and made an oil sketch of the mill (in the collection of Lord Binning) from which Fisher commissioned this painting. Constable delivered it during Fisher's visit to London in June 1824. Although the date on the stretcher is June 7, Fisher did not receive the painting for another two weeks. Constable wrote in his diary for Sunday, June 20: "Fisher took away his little picture of the Mill with a frame" (JCC II, p. 338).

Eighteen months later Constable painted a variant, about twice the size, for Mrs. Hand, a friend of the chancellor of the diocese of Salisbury; this version, exhibited at the Royal Academy in 1826, is now in the Yale Center for British Art.

IV. SALISBURY

So much does this city, by a singular chance, associate to my life.

> —Constable writing to John Fisher,
> November 26, 1825 (JCC VI, p. 210)

Does not the cathedral look very beautiful amongst the Golden foliage, its silvery grey must sparkle in it?

> —Constable writing to John Fisher,
> October 23, 1821 (JCC VI, p. 78)

31. Salisbury Cathedral from the Bishop's Grounds

Ottawa, National Gallery of Canada.
1820. Oil on canvas, 29¼ x 36⅜ in. (74.3 x 92.4 cm.).
COLL. Perhaps the artist's sale, Foster's, May 15–16, 1838 (part lot 12); ?Allnutt; Louis Huth, 1884; his sale, Christie's, May 20, 1905 (38); Colnaghi, 1905; Col. O. H. Payne; given by him to L. C. Ledyard; Agnew; bought, 1976.
LIT. H.367; Boston, 1946 (139); Graham Reynolds, *John Constable: Salisbury Cathedral from the Bishop's Grounds*, Masterpieces in the National Gallery of Canada 10, Ottawa, 1977 (rev. ed. in *A Dealer's Record, Agnew's 1967–81*, London, 1981, pp. 132–142).

Constable spent three weeks in Salisbury in September 1811 as the guest of the bishop, his old acquaintance Dr. John Fisher (see the entry for No. 25). It was on this visit that he formed the friendship with the bishop's nephew and namesake, John Fisher, which was to be one of the closest attachments of his life. Both on that first visit and during a brief stay on his return from his honeymoon in December 1816, Constable made some pencil drawings. The most productive of his visits, however, was the two-month holiday he spent with the younger Fishers — whose house Leydenhall was in the cathedral close — in July and August 1820, accompanied by his wife and two children. He made many drawings of the cathedral city and its neighborhood, as well as a number of oil sketches. Fisher, who was, as has been mentioned above (see No. 29), an amateur artist, lent him painting materials, including canvases, which enabled Constable to make his open-air sketches on a larger scale than usual. When writing to thank Fisher for his hospitality Constable remarked: "My Salisbury sketches are much liked — that in the palace grounds — the bridges — & your house from the meadows — the moat — &c." (JCC VI, p. 56). This sketch is probably "that in the palace grounds." It is certainly the picture to which the bishop's elder daughter, Dolly, referred when she wrote to Constable on October 8, 1820: "Papa desires me to say, he hopes you will finish for the Exhibition the view you took from our Garden of the Cathedral by the water side" (JCC VI, p. 58). It took Constable another two and a half years to complete this commission. For the exhibited picture of 1823 (now in the Victoria and Albert Museum, R.254) and the later versions of 1823 and 1826, see the entry for No. 34. This is the original sketch on which all those paintings are based.

X-ray examination has shown that Constable started the sketch as a vertical composition, with the canvas at right angles to its present direction.

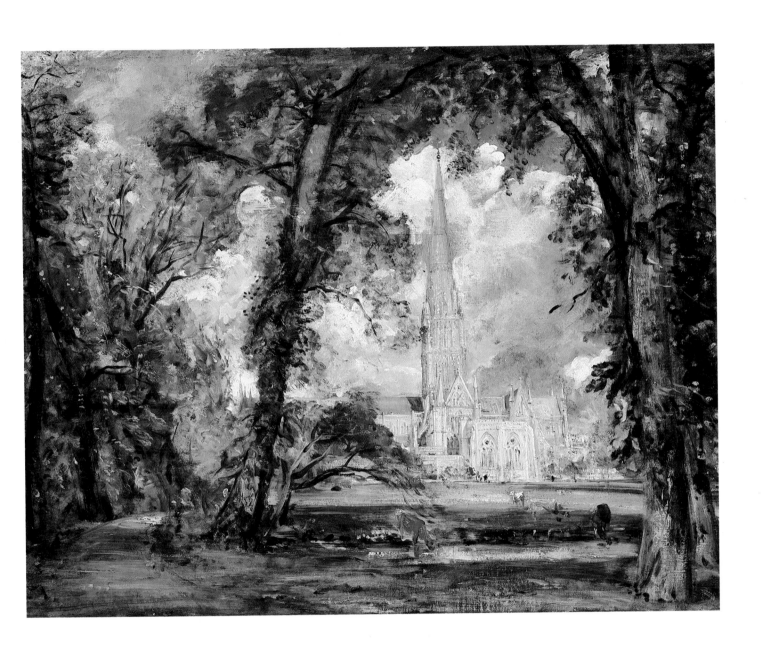

32. Salisbury Cathedral Seen Above the Close Wall

Cambridge, Fitzwilliam Museum (2383).
1820. Oil on canvas, 24 x 20⅜ in. (61 x 51.8 cm.).
COLL. A local sale, Hereford, 1925; Christie's, March 31, 1926 (92); Permain, 1926; Leggatt; Howard Young; Leggatt; Independent Gallery, 1927; F. Hindley Smith; bequeathed by him, 1939.
LIT. J. W. Goodison, *Fitzwilliam Museum, Cambridge: Catalogue of Paintings:* III. *British School*, Cambridge, 1977, pp. 47–48; H.282; Graham Reynolds, *John Constable: Salisbury Cathedral from the Bishop's Grounds*, Masterpieces in the National Gallery of Canada 10, Ottawa, 1977, p. 14.

This sketch shows the spire of Salisbury Cathedral on the left, above the wall of the cathedral close. The little bridge in the foreground crosses the stream that drained the bishop's fishpond into the river Avon.

The sketch is possibly the one that Constable calls "the moat" in his letter to John Fisher quoted in the previous entry. Both on grounds of style and for its viewpoint it is in any case probably one of his open-air sketches of 1820, rather than a work of 1829, as Goodison suggests.

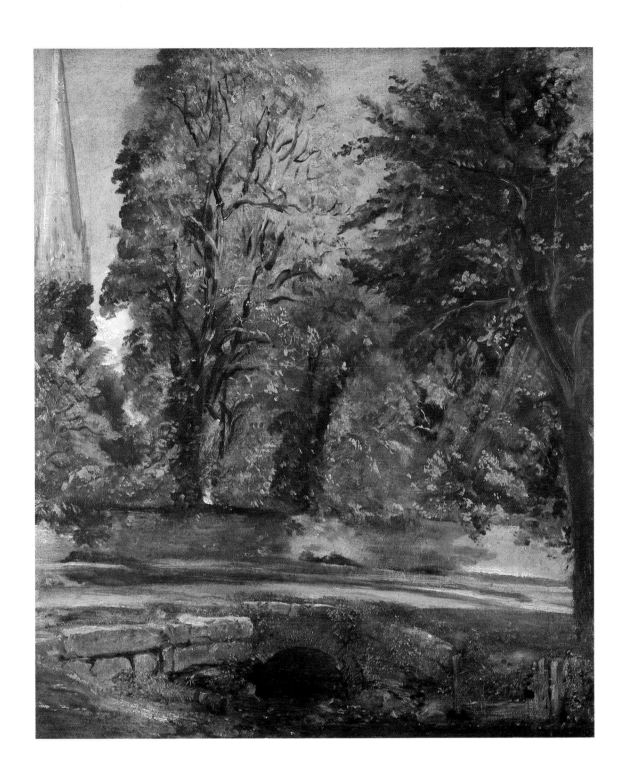

33. Harnham Gate, Salisbury

New Haven, Yale Center for British Art, Paul Mellon Collection (B1981.25.126).
1821. Oil on canvas, 21 x 20½ in. (53.3 x 52.1 cm.).
COLL. Probably the artist's sale, Foster's, May 15–16, 1838 (part lot 7); Bell; Saltmarsh; P. Wilding; Col. R. C.
Allhusen, 1961; Leggatt, 1961; Mr. and Mrs. Paul Mellon, 1961; given by them, 1981.
LIT. H.651; Richmond, 1963 (104); Washington, 1969 (28).

This large open-air sketch shows the medieval gate leading into Salisbury Close from the south. Constable followed up his 1820 visit with a three-week stay with John Fisher in November 1821. Beckett has convincingly suggested that the autumnal tones seen in the foliage suggest that the picture was painted on this visit, rather than on the summer holiday of 1820 discussed in the entries for Nos. 31 and 32.

Hoozee lists it among the works that he regards as doubtful. The brilliant brushwork, the use of the palette knife on the buildings at the right, and the dashing use of impasto, as well as the obvious accuracy of observation, are convincing evidence of its authenticity.

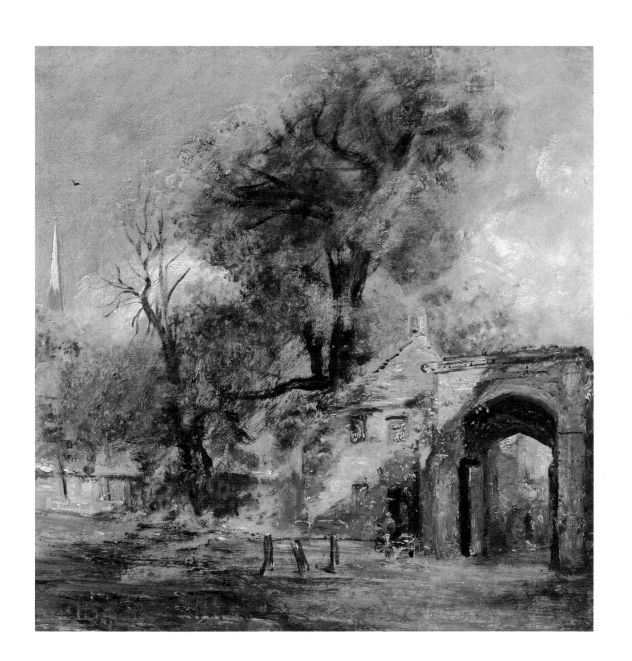

34. *Salisbury Cathedral from the Bishop's Grounds*

New York, The Metropolitan Museum of Art, Bequest of Mary Stillman Harkness, 1950 (50.145.8).
Ca. 1825–26. Oil on canvas, 34⅝ x 44 in. (87.9 x 111.8 cm.).
COLL. Probably the artist's sale, Foster's, May 15–16, 1838 (30); Archbutt; Davis; Foswell, 1907; Christie's, April 20, 1907 (104); ?Gribble; Sir Joseph Beecham, 1911; his sale, Christie's, May 3, 1917 (6); Smith, 1917; Agnew, 1923; Knoedler, 1926; Mr. and Mrs. Edward S. Harkness, 1926; bequeathed by Mrs. Edward S. Harkness, 1950.
LIT. H.657; R. B. Beckett, "Constable's 'Salisbury Cathedral from the Bishop's Grounds,'" *Art Quarterly*, XX, 1957, pp. 141–150; Graham Reynolds, *John Constable: Salisbury Cathedral from the Bishop's Grounds*, Masterpieces in the National Gallery of Canada 10, Ottawa, 1977, pp. 28, 34; C. S. Rhyne, "Constable Drawings and Watercolors in the Collections of Mr. and Mrs. Paul Mellon and The Yale Center for British Art: Part I. Authentic Works," *Master Drawings*, XIX, 1981, p. 139 n. 2.

As recorded in the entry for No. 31, Bishop Fisher saw the open-air sketch that Constable had made in 1820 of Salisbury Cathedral as it appeared from the grounds of the bishop's palace, and commissioned him to finish it for exhibition at the Royal Academy. Rather than work any further on his sketch, Constable chose to paint a slightly larger version. With difficulty he completed this for the Academy exhibition of 1823; it is now in the Victoria and Albert Museum (R.254). The bishop approved of the composition and its topographical accuracy, but never of the rain clouds that Constable had observed when making the sketch and transferred emphatically to the exhibited picture. Accordingly, when in 1823 the bishop commissioned a smaller replica (now in the Huntington Library and Art Gallery, San Marino) as a wedding present for his daughter Elizabeth, he asked Constable to put it "into a little sunshine." Dr. Fisher's continuing dissatisfaction with the first finished version led him to return it to Constable for a similar lightening of the atmosphere and a "more serene sky." Constable chose to paint him an entirely new version, with a lighter sky and thinned-out trees, no longer meeting in an arch above the cathedral spire. The bishop, who died on June 25, 1825, did not live to receive this picture, which was delivered to his widow in 1826; it is now in the Frick Collection, New York. When making these later versions, Constable had some help in laying in the outlines from his studio assistant John Dunthorne junior. No. 34 is a studio sketch for the bishop's second version. As was frequently his practice, Constable worked out the effect of his atmospheric and compositional changes on a canvas of the size intended for the final picture. The sketch is unfinished in the tree trunks, branches, and foliage, and in the architectural detail, but Constable has approached completion so nearly in other respects that he has included the butterfly hovering near the bush at the left, which appears in the Frick painting.

In the left foreground the bishop is seen proudly pointing out the spire of the cathedral to his wife. One of their daughters is advancing along the path towards her parents. These figures were regarded as recognizable likenesses: "Constable has put the Bishop & Mrs. F. as figures in his view very like & characteristic" (John Fisher to his wife, June 4, 1823; JCC VI, p. 120).

Hoozee lists this among the works that he regards with suspicion. As Rhyne has pointed out, this judgment can only be accounted for by the fact that Hoozee had not had the opportunity to study the picture at first hand. It is certainly authentic.

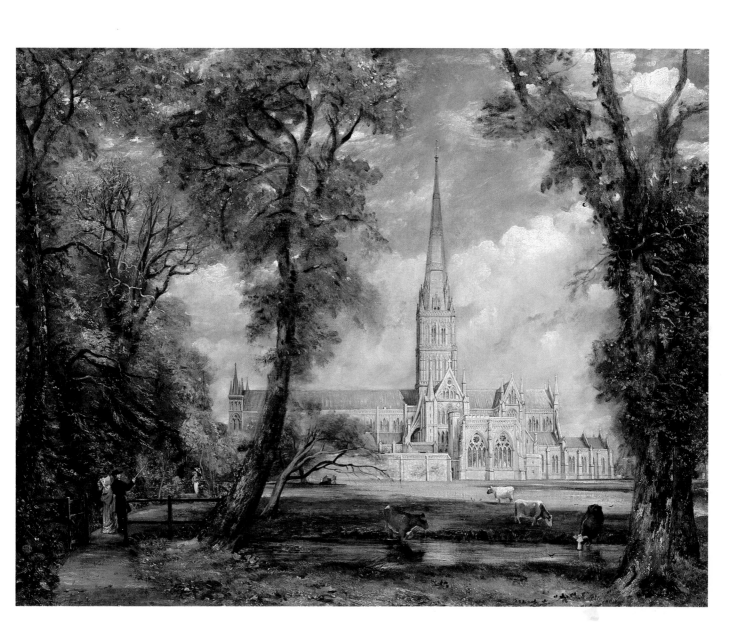

35. *A View at Salisbury from John Fisher's House*

London, Victoria and Albert Museum (320-1888).
1829. Oil on canvas, 7⅞ x 9⅞ in. (20 x 25.1 cm.).
A label on the stretcher is inscribed: *Lionel 1848 Jany*. The stretcher is inscribed: *borrowed by C. R. Leslie May 20th. 1841*.
COLL. Lionel Bicknell Constable; Isabel Constable; given by her, 1888.
LIT. R.320; H.515.

Constable's wife, Maria, died on November 23, 1828, a loss from which his spirits never fully recovered. Fisher urged him to visit Salisbury the following year, and Constable stayed with him at his house Leydenhall in the cathedral close for three weeks in July 1829. He returned for another short visit in November of the same year, mainly to continue the preparations for the painting *Salisbury Cathedral from the Meadows* (now in the collection of Lord Ashton of Hyde), which was the major undertaking to arise from this fresh experience of Salisbury. Fisher's company and the return to scenes where he had been happy in the past had so calming an effect on Constable's disturbed emotions that he painted a number of sketches which reflect a mood of tranquillity. He has reverted in them to the early, liquid manner of his open-air sketching around 1820, and this leads to some hesitation in assigning dates to sketches such as this, which are not inscribed by the artist. But No. 35 is so similar in size and viewpoint to a dated sketch of July 1829 in the Victoria and Albert Museum (R.311) that it can reasonably be supposed to have been painted during the same stay. The dated sketch is a view from Fisher's library window; the scene in No. 35 is also taken from one of the windows of his house.

36. Old Sarum

London, Victoria and Albert Museum (163-1888).
1829. Oil on card, 5⅝ x 8¼ in. (14.3 x 21 cm.).
The back of the card is ruled as a watercolor mount and inscribed: *ML*.
Engraved in mezzotint by David Lucas for *English Landscape Scenery* and published in the second part, 1830 (see fig. 12);
engraved again by Lucas for the second edition, 1833.
COLL. Maria Louisa Constable; Isabel Constable; given by her, 1888.
LIT. R.322; H.516.

The oil sketch shows the mound of Old Sarum from the same aspect as a pencil drawing in the Yale Center for British Art (B1977.14.4631), which is dated July 20, 1829. It was probably painted in the studio from the drawing, rather than as a separate study from nature. It cannot be later than the end of 1829, when the first of Lucas's mezzotints from it was started. Constable was not satisfied with the definition given to the terraces in that plate, and in the second edition of *English Landscape Scenery*, 1833, replaced it by another mezzotint of the subject by Lucas.

Old Sarum, a mound one and a half miles north of Salisbury, is the site of the original episcopal see. After continuing trouble with the military authorities, the see was transferred to Salisbury (New Sarum) in the thirteenth century, when the present cathedral was built, and the old town was gradually deserted and eventually razed to the ground. A text that Constable prepared to accompany the engraving dwelt upon the fascination of the place as a ruined city; he associated the site with the grander aspects of nature, stormy skies, evening light, and solemn effects of shade. He chose as part of the engraved title for the second plate the quotation from St. Paul: "Here we have no continuing city" (Hebrews 13:14).

Sir Thomas Lawrence admired the plate shortly before his death on January 7, 1830, and suggested that it should be dedicated to the House of Commons. Lawrence may have had in mind the fact that the first Parliament was held at Old Sarum, by a writ of King John directed to the bishop of Salisbury in 1205. On the other hand, he may have been referring to the notoriety of Old Sarum as a "rotten borough"—returning two members to Parliament with an electorate of seven—and a conspicuous object lesson for the advocates of parliamentary reform.

V. HAMPSTEAD

I am three miles from door to door — can have a message in an hour — & I can get always away from idle callers — and above all see nature — & unite a town & country life.

—Constable writing to John Fisher
about his plan to buy a permanent home
in Hampstead, November 28, 1826
(JCC VI, p. 228)

37. Hampstead Heath, Looking Towards Harrow

London, Royal Academy of Arts.
1821. Oil on paper laid on canvas, 9⅜ x 11¾ in. (23.8 x 29.8 cm.).
Inscribed on the back of the stretcher: *Hampstead July 14 1821 6 to 7 P.M. N.W. breeze strong.*
COLL. Isabel Constable; given by her, 1888.
LIT. H.294; Tate, 1976 (194); Thornes, p. 20 (1).

Constable had written weather notes on some of the watercolor drawings he made in the Lake District in 1806. He reverted to this practice in his open-air sketching at Hampstead, from 1820 onward. This sketch bears the earliest dated weather notes for 1821.

The evening view is from Judges Walk on the top of the ridge of Hampstead Heath, looking west with Harrow Hill and the spire of Harrow church seen on the extreme left.

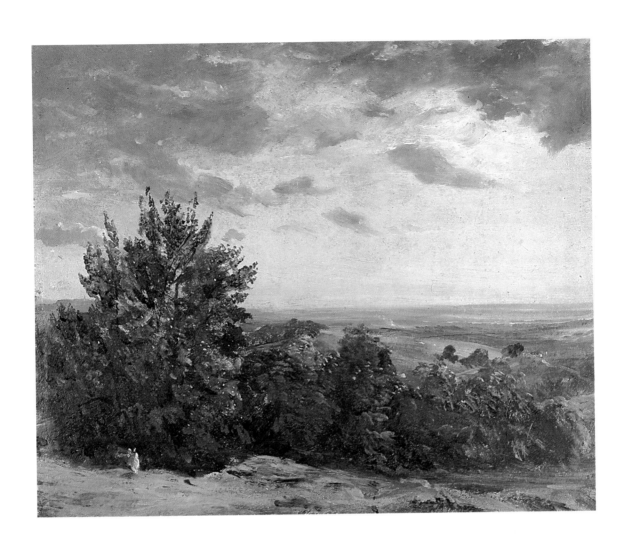

38. *View from Hampstead Heath, Looking Towards Harrow*

Manchester City Art Gallery (1917.176).
1821. Oil on paper laid on canvas, 9⅞ x 11¾ in. (25 x 29.8 cm.).
Inscribed on a label pasted on the stretcher: *August 1821 5 Oclock afternoon: very fine bright & wind after rain slightly in the morning.*
COLL. Isabel Constable; Leggatt; James Blair; bequeathed by him, 1917.
LIT. *Manchester City Art Gallery: Concise Catalogue of British Paintings*, I, Manchester, 1976, p. 36; H.297.

Branch Hill Pond is in the foreground, and Harrow Hill and church are conspicuous in the distance slightly left of center. Although the sketch has often been called "Sunset," it is an afternoon scene, with the sun westering through clouds over Harrow.

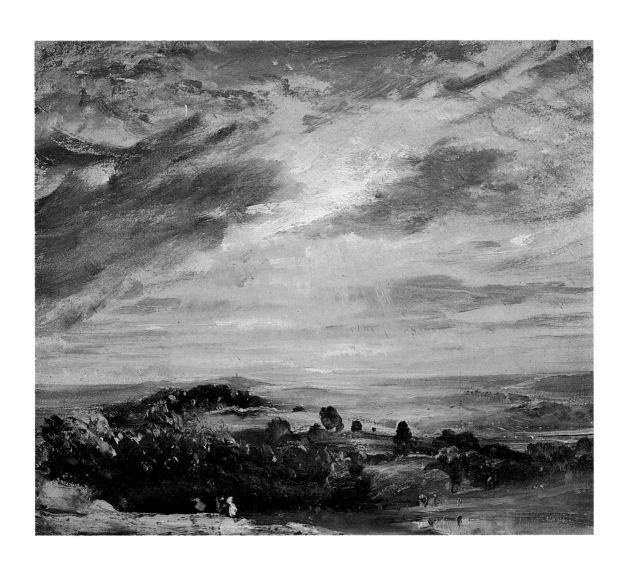

39. Study of Clouds at Hampstead

London, Royal Academy of Arts.
1821. Oil on paper laid on board, 9½ x 11¾ in. (24.2 x 29.8 cm.).
Inscribed by the artist: *Hampstead, Sep*r *11, 1821. 10. to 11. Morning under the Sun — Clouds silvery grey, on warm ground*
Sultry. Light wind to the S.W. fine all day — but rain in the night following.
COLL. Isabel Constable; given by her, 1888.
LIT. H.300; Detroit/Philadelphia, 1968 (126); Thornes, p. 20 (3).

Apart from the glimpse of trees at the lower right this is a cloud study, and as such one of the earliest dated examples of that type of open-air sketch by Constable. It shows small cumulus clouds in the southwesterly airstream. The fact that Constable mentions rain the following night shows that his weather notes were sometimes added a day or so later, from memory or from rough memoranda made at the time of sketching.

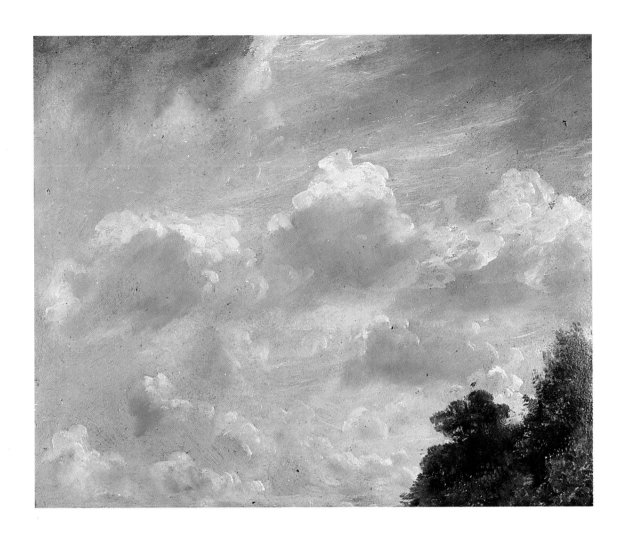

40. Study of Sky and Trees at Hampstead

London, Victoria and Albert Museum (168-1888).
1821. Oil on paper, 9⅝ x 11¾ in. (24.5 x 29.8 cm.).
Inscribed in ink by the artist on the back: *Ocr. 2d. 1821. 8. to 9. very fine still morning. turned out a may day. Rode with Revd. Dr. White. round by Highgate. Muswell Hill. Coney Hatch. Finchley. by Hendon Home.* Also inscribed in ink with the monogram: *JC.*
COLL. Isabel Constable; given by her, 1888.
LIT. R.226; H.311; Thornes, pp. 21–22 (10).

During the period in which he was painting pure cloud studies such as Nos. 39 and 43, Constable also made a number of sketches of the sky above foliage set in motion by the wind and lit by the sun. The rooftop and chimneys to the right of the bushes in the foreground are seen from above, showing that the viewpoint is on rising ground at Hampstead—possibly from the garden of the house at 2 Lower Terrace, which he had rented for the summer of 1821.

The neighbor with whom he made the ride of some fifteen miles may be the "Dʳ White so very fat!" to whom he refers in a letter of October 25, 1833, to his eldest son, John Charles (JC:FDC, p. 89).

41. *Hampstead Heath, Looking Towards Harrow*

New Haven, Yale Center for British Art, Paul Mellon Collection (B1976.7.103).

1821. Oil on paper laid on canvas, 10¼ x 12¾ in. (26 x 32.5 cm.).

A label fixed to the back of the stretcher is inscribed, probably by Capt. Charles G. Constable copying the artist's original inscription: *Hampstead 31ˢᵗ Oct. 1821. Very fine afternoon of a beautiful day, it began with rain. Wind fresh from West.* Also inscribed: *This was painted on Hampstead Heath in 1821 by my Father, John Constable, R.A., and presented by me to A. W. Stiffe A.D. 1863. Charles Golding Constable.* In pencil on the canvas is *C. G. Constable* and [?*Artists*] (struck through).

COLL. Capt. Charles Golding Constable; given by him to A. W. Stiffe, 1863; bequeathed by him to his grand-daughter, A. C. Stephens; her sale, Christie's, June 21, 1974 (115); Mr. and Mrs. Paul Mellon, 1974; given by them, 1976.

LIT. H.319.

This is one of the two evening studies that Constable mentioned to Fisher in his letter of November 3, 1821: "The last day of Octʳ was indeed lovely, so much so that I could not paint for looking—my wife was walking with me all the middle of the day on the beautiful heath. I made two evening effects" (JCC VI, p. 81). The view appears to be of Judges Walk with Harrow Hill and church to the left of center. The roughly painted figures on the right include a little girl in red and pink, and a lady with a yellow bonnet trimmed with black.

42. The Road to The Spaniards, Hampstead

Philadelphia, The John G. Johnson Collection (J.858).
1822. Oil on paper laid on canvas, 12¼ x 20½ in. (31.1 x 52.1 cm.).
Inscribed, not by the artist, on an old label fixed to the back: *[Hamp]stead. Monday 2[2 or 9] July 1822 looking N E*
3 P M [?previous] to a thunder squall wind N West.
COLL. Probably Capt. Charles Golding Constable; his widow, Mrs. A. M. Constable; his sale, Christie's, July 11,
1887 (82); Agnew, 1887; T. Wright; Agnew, 1894; John G. Johnson, 1894.
LIT. H.331; Boston, 1946 (132); Tate, 1976 (204); Thornes, p. 22 (14).

The Spaniards, existing to this day, is an inn on the road that runs from Hampstead to Highgate along the ridge at the top of Hampstead Heath. It is seen here in the clump of trees to the left.

The label on the back evidently copies an inscription by the artist. The date has hitherto been read as "2 July 1822," leading to difficulties in reconciling the weather noted by Constable with other records for that day. There is, however, an old break in the paper at this point, making it possible to read the date either as "Monday 22 July" or as "Monday 29 July."

The sketch, on a scale that Constable adopted in 1822 for his larger sky studies, such as Nos. 43 and 44, appears from the inscription to have been made in the open air.

43. Study of Cumulus Clouds

New Haven, Yale Center for British Art, Paul Mellon Collection (B1981.25.144).
1822. Oil on paper laid on canvas, 12 x 20 in. (30.5 x 50.8 cm.).
Inscribed by the artist on a label fixed to the stretcher: *Augt 1. 1822 11 o clock A.M. very hot with large climbing Clouds under the Sun. wind westerly.*
COLL. Sir Michael Sadler; Dr. H. A. C. Gregory; his sale, Sotheby's, July 20, 1949 (126); Colnaghi, 1949; Gilbert Davis; Mr. and Mrs. Paul Mellon; given by them, 1981.
LIT. H.337; Washington, 1969 (51); Thornes, p. 23 (19).

Writing to John Fisher from Hampstead on October 7, 1822, Constable gave an account of his recent activities and remarked: "I have made about 50 careful studies of *skies* tolerably large, to be careful" (JCC VI, p. 98). This sketch is the earliest pure cloud study in the larger size to be fully dated and inscribed by the artist.

44. *Cloud Study*

London, Courtauld Institute Galleries.
1822. Oil on paper laid on board, 12 x 19¼ in. (30.5 x 49 cm.).
Inscribed on the back in ink by the artist: *Sep! 21 1822. looking South brisk wind at East Warm & fresh. 3 oclo afternoon.*
Also numbered on the back in pencil: *5.*
COLL. Paterson Gallery, 1928; Sir Farquhar Buzzard; Miss T. Creke-Clark; bequeathed by Sir Robert Witt with a life interest to Miss Creke-Clark (d. 1974).
LIT. H.348; Thornes, pp. 24–25 (27).

This is the second of two large pure cloud studies painted in quick succession. The earlier, made at 1:30 p.m. on the same day, is in the Yale Center for British Art. Both show an easterly air flow with streets of "fair weather" cumulus clouds.

45. *Branch Hill Pond, Hampstead Heath*

Richmond, Virginia Museum of Fine Arts (49.18.4).
1825. Oil on canvas, 24½ x 30¾ in. (62.2 x 78.1 cm.).
EXH. Royal Academy, 1825 (115).
COLL. Bought from the artist by Francis Darby, 1825; by descent to his son, Alfred Darby; Agnew; Sir Joseph Beecham; his sale, Christie's, May 3, 1917 (8); Agnew, 1917; Knoedler, 1918; Chester Johnson; Mrs. F. Weyerhauser; Newhouse; A. D. Williams; given by Mrs. A. D. Williams, 1949.
LIT. H.441; Tate, 1976 (239) and p. 201, 1825 n.5; P., pp.117–118.

This is a view from the ridge at the top of Hampstead Heath looking over Branch Hill Pond; Constable repeated the composition more than once. Taken from a viewpoint slightly higher and further to the right than that adopted for his other standard view over Branch Hill Pond, seen in No. 46, it is one of a pair of Hampstead scenes that Constable regarded as inseparable pendants; the other represented Child's Hill with Harrow in the distance. He described the present picture in a letter of August 1, 1825, to the purchaser, Francis Darby, as "A scene on Hampstead Heath, broken foreground and sand carts, Windsor Castle in the extreme distance on the right of the shower. The fresh greens in the distance (which you are pleased to admire) are the fields about Harrow, and the villages of Hendon, Kilburn, &c." (JCC IV, p. 97).

John Arrowsmith, who had bought *The Hay Wain* and *View on the Stour near Dedham* for exhibition at the Paris Salon in 1824, introduced another French dealer, Claude Schroth, to Constable that May. Schroth promptly commissioned three paintings, two of which were to be Hampstead views. Constable decided to make virtually identical replicas of this scene and its pendant in fulfillment of the order. Schroth's version of No. 45 is now in Switzerland, in the Oskar Reinhart Foundation, Winterthur.

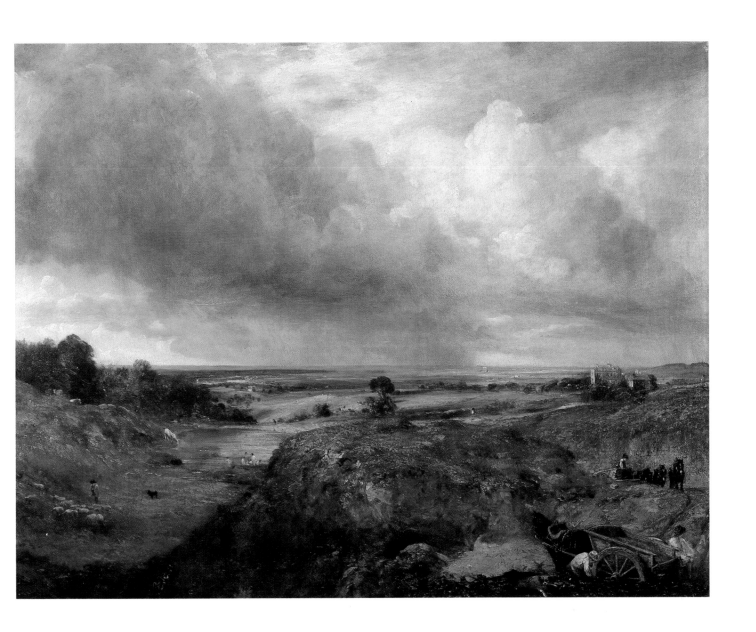

46. Branch Hill Pond, Hampstead Heath

The Cleveland Museum of Art, Purchase, Leonard C. Hanna, Jr. Bequest (72.48).
1828. Oil on canvas, 23⅞ x 30¾ in. (60.6 x 78 cm.).
COLL. Painted for Henry Hebbert; by descent to his son, Henry Hebbert, 1863; Christie's, April 21, 1894 (126); Tooth; Cyrus McCormick; by descent until 1958; Hirschl and Adler, 1958; Leggatt, 1959; Earl of Inchcape; Thaw; bought, 1972.
LIT. H.482; William S. Talbot, "John Constable: Branch Hill Pond, Hampstead Heath," *Bulletin of the Cleveland Museum of Art*, LXI, 1974, pp. 97–115; Tate, 1976, p. 201, 1827 n.1.

This view over Branch Hill Pond is taken from a slightly different point from that adopted for No. 45. It is a replica of the painting that Constable exhibited at the Royal Academy in 1828 (now in the Victoria and Albert Museum, R.301). The first owner of the present version, Henry Hebbert, had wished to buy No. 45 and its pendant, but reverses in trade forced him to relinquish the purchase to Francis Darby. He still wanted a view or pair of views of Hampstead by Constable, and it appears that Constable made this replica of his successful Academy exhibit to satisfy Hebbert's wish.

The composition of both versions is based upon one of the first oil sketches Constable made in Hampstead, dated to the end of October 1819 (Victoria and Albert Museum, R.171).

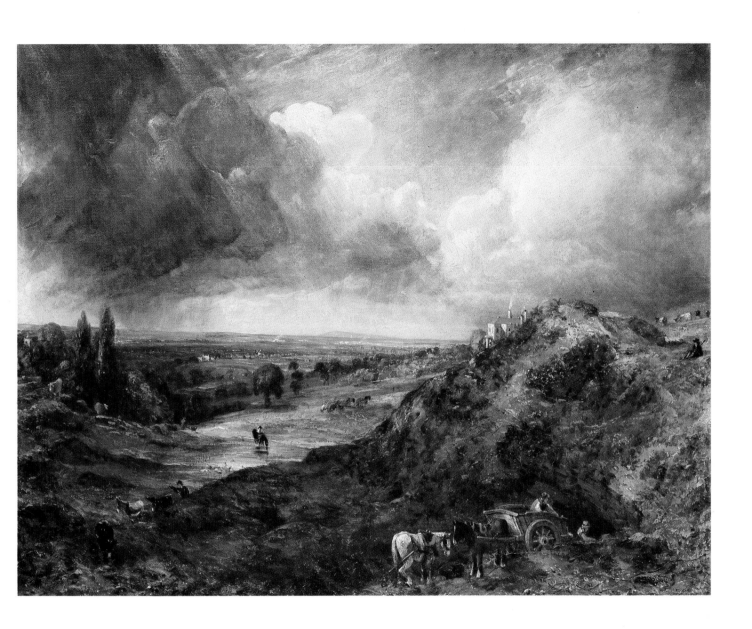

VI. BRIGHTON

Brighton is the receptacle of the fashion and offscouring of London. . . . the beach is only Piccadilly . . . by the sea-side. . . . In short there is nothing here for a painter but the breakers — & sky — which have been lovely indeed and always varying.

—Constable writing to John Fisher,
August 29, 1824 (JCC VI, p. 171)

The neighbourhood of Brighton—consists of London cow fields—and Hideous masses of unfledged earth called the country.

—Inscription by Constable on the back
of a study of a windmill near Brighton,
August 3, 1824 (Victoria and Albert
Museum, R.268)

47. Brighton Beach

London, Victoria and Albert Museum (335-1888).
1824. Oil on paper, 6½ x 12 in. (16.5 x 30.4 cm.).
Inscribed on the back in ink by the artist: *Beach Brighton 22d July, 1824 Very fine Evening.* In another hand: *Painted by J. Constable at Brighton.*
COLL. Isabel Constable; given by her, 1888.
LIT. R.267; H.415.

In his letter to John Fisher of August 29, 1824, an excerpt of which has been quoted above, Constable wrote: "The fishing boats are picturesque, but not so much so as the Hastings boats, which are luggers" (JCC VI, p. 171). He added that such subjects were "so hackneyed in the Exhibition" and had done a great deal of harm by appealing to the taste of people who would otherwise have begun to appreciate pastoral landscape.

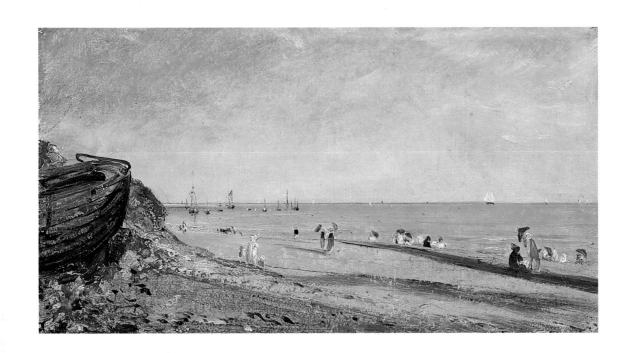

48. A Coast Scene at Brighton

Philadelphia, Collection of Henry P. McIlhenny.
Ca. 1824–28. Oil on board, 10 x 16⅝ in. (25.4 x 42.2 cm.).
COLL. Capt. Charles Golding Constable; his sale, Christie's, June 23, 1890 (77); Colnaghi; John D. McIlhenny; by descent to the present owner.

Although the description "at Brighton" has been added to the title since the sale of the picture from the family collection in 1890, it is probably correct. In spite of his unflattering descriptions of Brighton, Constable made many sketches there which show his enthusiastic response to the coastal atmosphere and the effects of light upon the sea.

49. *Sailing Ships off the Coast at Brighton*

Private collection.
Ca. 1824–28. Oil on paper laid on canvas, 11¾ x 19 in. (29.8 x 48.3 cm.).
Fixed to the back are a number of press reviews, dated between June 5 and 24, 1893, of an exhibition in which this painting was included.
COLL. Capt. Charles Golding Constable; his widow, Mrs. A. M. Constable; his sale, Christie's, July 11, 1887 (84); Agnew, 1888; Dowdeswell; Sedelmeyer, 1894; Knoedler, 1903; private collection; by descent to the present owner.

When this sketch was lent by Captain Charles Golding Constable's widow to the South Kensington Museum in 1880 it was described simply as "A seascape, with stormy effect." There can be little doubt that it is one of the studies that Constable made at Brighton between 1824 and 1828. The shipping, which carries more sail than is usual in his scenes off this coast, may consist of the coal brigs which beached at Brighton, and which had a special interest for Constable in view of his family's connection with the coaling trade between London and Suffolk. He frequently made drawings and oil sketches of these vessels at Brighton.

50. *Rainstorm off the Coast at Brighton*

London, Royal Academy of Arts.
Ca. 1824–28. Oil on paper laid on canvas, 8¾ x 12¼ in. (22.2 x 31 cm.).
COLL. Isabel Constable; given by her, 1888.
LIT. H.496; Tate, 1976 (233).

This study of a shower of rain over the sea is one of the most intensely observed and dramatic of Constable's studies of passing appearances and the "phenomena of Nature." Although uninscribed it was evidently painted between 1824 and 1828, during one of his visits to Brighton.

51. Hove Beach

New Haven, Yale Center for British Art, Paul Mellon Collection (B1981.25.157).
Ca. 1824–28. Oil on paper laid on board, 9⅛ x 14⅛ in. (23 x 36 cm.).
COLL. Colnaghi; Mr. and Mrs. Paul Mellon; given by them, 1981.
LIT. H.424; Washington, 1969 (59).

Hove is a resort town at the west end of Brighton, and Constable made some of his stormiest and most rugged sketches from its beach. The sun setting in the west indicates that this is an evening study. It would have been painted on one of Constable's visits to Brighton between 1824 and 1828.

52. A Sea Beach

The Detroit Institute of Arts, Bequest of Mr. and Mrs. Edgar B. Whitcomb (53.364).
Ca. 1824–28. Oil on paper laid on canvas, 12⅝ x 19¾ in. (32.1 x 50.2 cm.).
Engraved in mezzotint by David Lucas for *English Landscape Scenery*, and published in the second part, 1830.
COLL. Capt. Charles Golding Constable; his widow, Mrs. A. M. Constable; his sale, Christie's, July 11, 1887 (71);
Noseda; J. P. Heseltine; Langton Douglas; Mr. and Mrs. Edgar B. Whitcomb; bequeathed by them, 1953.
LIT. H.483.

Constable made only one large painting from his Brighton sketches — *Marine Parade and Chain Pier, Brighton* (fig. 8), exhibited in 1827, a majestic work which embodies his anxiety over the deterioration in his wife's health that the Brighton air was supposed to arrest. But he chose No. 52 to represent the wild vigor of the Brighton coast in *English Landscape Scenery*. Around 1834 he intended to publish descriptive letterpress for each of the plates, and although this came to nothing he drafted a text for *A Sea Beach, Brighton*. This begins with the quotation of some lines by the poet George Crabbe:

> But nearer land you may the billows trace,
> As if contending in their watery chase;
> Curl'd as they come they strike with furious force
> And then re-flowing, take their grating course.
> (*The Borough*, "Letter 1")

He then explains that the subject of the plate is the wave seen from the shelter of a groin: "It seems overwhelming in its approach — at the same time, from its transparency, becoming illumined by the freshest and most beautiful colours." He goes on to claim that nothing in creation is more imposing than the ocean and that there is no more exhilarating scene than a sea beach. The print, he says, shows:

> one of those animated days when the masses of clouds, agitated and torn, are passing rapidly; the wind at the same time meeting with a certain set of the tide, causes the sea to rise and swell with great animation. . . . In such weather the voice of a solitary sea-fowl is heard from time to time. . . . These birds, whether solitary or in flocks, add to the wildness and to the sentiment of melancholy always attendant on the ocean. (JCD, pp. 19–20)

There follows an enthusiastic account of the growth, the fashionable quality, the climate, and the flora of Brighton, which is in direct opposition to Constable's earlier sentiments as expressed in his letter to Fisher quoted at the head of this section; this part of the text appears to have been written by his friend the horticulturist Henry Phillips, who had laid out the public gardens in Brighton and whom he had consulted about the wild flowers in *The Cornfield* (No. 23).

VII. LONDON

I am hardly yet got reconciled to brick walls and dirty streets, after leaving the endearing scenes of Suffolk.

—Constable writing to Maria Bicknell
from Charlotte Street, London,
November 12, 1814 (JCC II, p. 136)

53. A Scene in a Park

London, Royal Academy of Arts.
?1823. Oil on paper laid on board, 9½ x 11½ in. (24.2 x 29.2 cm.).
COLL. Isabel Constable; given by her, 1888.
LIT. H.398.

The back of the stretcher bears a copy of an inscription relating to another oil sketch in the collections of the Royal Academy, made at Hampstead at 4 p.m. on September 27, 1821 (fig. 7). There is, however, no reason to connect No. 53 with Hampstead. In style it resembles an oil sketch of August 6, 1823, in the Victoria and Albert Museum (R.255), and it may have been made in that year.

It seems possible that the scene is in Green Park looking towards Apsley House with Constitution Hill in the foreground and on the left. If so, it is one of the few parklike scenes that Constable painted in central London.

54. *The Thames and Waterloo Bridge*

Cincinnati Art Museum, Gift of Mary Hanna (1946.109).
?1820 or 1824. Oil on canvas, 21¾ x 30¾ in. (55.2 x 78.1 cm.).
COLL. Mrs. H. J. S. Nightingale; Robinson & Foster's, July 2–4, 1928 (106); Mary Hanna; given by her, 1946.
LIT. H.265; Detroit/Philadelphia, 1968 (129).

The long-drawn-out story of Constable's resolve to paint a picture of the ceremonial opening of Waterloo Bridge in 1817 is referred to in the entry for No. 57. Constable also painted a topographical view of the new bridge and the reach of the Thames which it spanned. The references to "Waterloo Bridge" in his correspondence are sometimes ambiguous and might refer to one project or the other. Accordingly there is no direct evidence for the date of this version. It may be the "London and Westminster view" about which John Fisher wrote to Constable on April 19, 1820. Equally, it may be the "little Waterloo bridge" which Constable told Fisher in January 1824 that he had painted as "a small balloon to let off as a forerunner to the large one."

This painting is an enlarged version of an oil sketch in the Royal Academy, London, which is itself derived from a drawing made on the spot and now in a private collection.

55. Sketch for *The Opening of Waterloo Bridge*

Private collection.
?1819. Oil on canvas, 6 x 8¾ in. (15.2 x 22.3 cm.).
COLL. Sotheby's, November 30, 1960 (122); private collection; by descent to the present owner.
LIT. H.262.

Among the early landmarks in the history of No. 57 is the entry in Joseph Farington's Diary for August 11, 1819:

> Constable called, and brought a painted sketch of his view of Waterloo bridge &c and the river as it appeared on the day of the *opening the Bridge*. I objected to his having made it so much a "*Birds eye view*" and thereby lessening magnificence of the bridge & buildings. — He s.^d he would reconsider his sketch.

Of all the known preparatory material for the exhibited picture, the present sketch comes closest to Farington's description of a bird's-eye view. In any event, it represents an early phase in the planning of the completed work.

56. The Opening of Waterloo Bridge

New Haven, Yale Center for British Art, Paul Mellon Collection (B1977.14.44).
?1829. Oil on canvas, 24⅜ x 39 in. (62 x 99 cm.).
Engraved in mezzotint by David Lucas; the plate, intended for *English Landscape Scenery*, was begun in 1829, but not
published until 1838, after Constable's death.
COLL. Camille Groult; Pierre Bordeaux-Groult; Agnew, 1960; Mr. and Mrs. Paul Mellon, 1970; given by them, 1977.
LIT. H.546; Graham Reynolds, "Constable at Work," *Apollo*, XCVI, 1972, pp. 15-17.

This is a half-scale sketch for No. 57, the painting that Constable exhibited in 1832. Although much about the history of the preparations for that painting is obscure, this study was certainly in existence by 1829, when Constable put in hand the engraving of it by David Lucas.

In the final version Constable introduced the parapet of a terrace in the foreground.

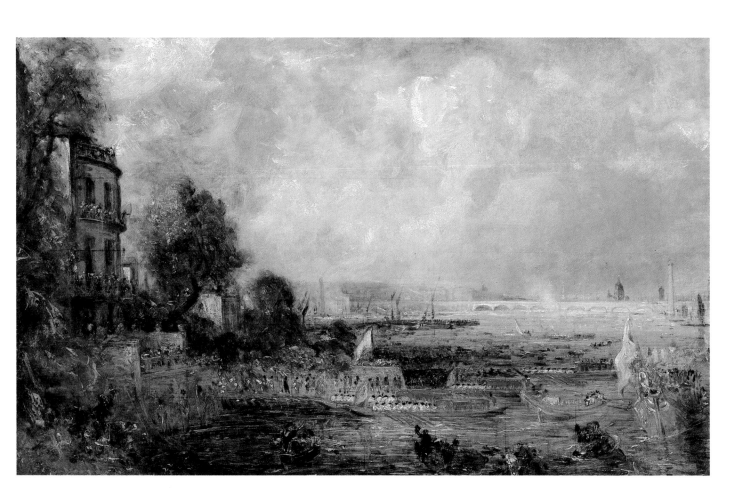

57. The Opening of Waterloo Bridge
Seen from Whitehall Stairs, June 18th, 1817

Private collection.
1832. Oil on canvas, 53 x 86½ in. (134.6 x 219.7 cm.).
EXH. Royal Academy, 1832 (286).
COLL. The artist's sale, Foster's, May 15–16, 1838 (74); Moseley, 1838; Charles Birch, 1839; Christie's, July 7, 1853 (42), bought in; Foster's, February 27, 1857 (LXVI); Henry Wallis, 1857; Foster's, February 3, 1858 (104), bought in; Foster's, February 6, 1861 (86); Davenport, 1861; Kirkman D. Hodgson; Sir Charles Tennant, 1892; by descent to Lord Glenconner; Harry Ferguson, 1955; present owner.
LIT. H.545; Denys Sutton, "Constable's 'Whitehall Stairs' or 'The Opening of Waterloo Bridge,'" *Connoisseur*, CXXXVI, 1956, pp. 249–255; Tate, 1976 (286).

The Prince Regent opened Waterloo Bridge, designed by John Rennie, on the second anniversary of the battle of Waterloo, June 18, 1817. It was a popular and colorful public event. Constable witnessed it from Whitehall Stairs, from which the prince embarked in the royal barge to sail to the bridge, accompanied by the Lord Mayor of London in his own barge. Constable appears to have made a drawing of the scene at the time, and two years later decided to paint a large picture showing the ceremony. He intended to exhibit this at the Royal Academy, first in 1821 and, when he had not done so, again in 1824, but was persuaded not to interrupt the flow of Suffolk scenes which had been his principal contributions in those years. After further procrastination and a fresh start on a new canvas he eventually showed the picture at the Academy of 1832, thirteen years after he had first conceived it. The references in the correspondence to his starts and restarts are confusing, and some appear to refer to the topographical view of Waterloo Bridge without the opening ceremonial (No. 54).

The painting, to which Constable referred as "my Harlequin's Jacket," is exceptional in his oeuvre in the high tonality of its color. This spurred Turner into competition; during the varnishing days before the exhibition opened, he added a scarlet buoy to his *Helvoetsluys*, which was hanging nearby. Bishop Fisher and Sir Thomas Lawrence, who saw *The Opening of Waterloo Bridge* at earlier stages, admired it, but when Constable sent the picture to the exhibition his friend the painter Thomas Stothard remarked: "Very unfinished, Sir." As was his custom with his large Academy exhibits, Constable worked on the canvas after it had returned to his studio.

A full-size study for this painting is at Anglesey Abbey (National Trust).

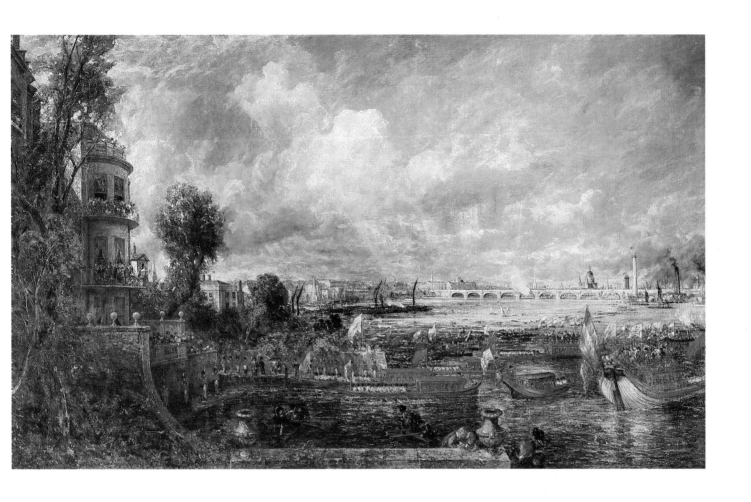

VIII. HADLEIGH, ESSEX

I walked upon the beach at South End. I was always delighted with the melancholy grandeur of a sea shore. At Hadleigh there is a ruin of a castle which from its situation is really a fine place—it commands a view of the Kent hills, the Nore and North Foreland & looking many miles to sea.

—Constable writing to Maria Bicknell,
July 3, 1814 (JCC II, p. 127)

58. *Hadleigh Castle*

New Haven, Yale Center for British Art, Paul Mellon Collection (B1977.14.42).
1829. Oil on canvas, 48 x 64¾ in. (122 x 164.5 cm.).
The composition was engraved twice in mezzotint by David Lucas: the larger plate was begun by February 1829 but not published until 1849; the smaller plate was published in the fifth number of *English Landscape Scenery*, 1832.
EXH. Royal Academy, 1829 (322).
COLL. The artist's sale, Foster's, May 15–16, 1838 (78); Tiffin, 1838; Hogarth; his sale, Christie's June 13, 1851 (46); Winter; Louis Huth, 1863; private collection, U.S.A., until 1960; Agnew, 1961; Mr. and Mrs. Paul Mellon, 1961; given by them, 1977.
LIT. H.502; Richmond, 1963 (113); Washington, 1969 (61); Tate, 1976 (263); Malcolm Cormack, "In Detail: Constable's *Hadleigh Castle*," *Portfolio*, Summer 1980, pp. 36–40.

Hadleigh Castle is a thirteenth-century building on a hill some 150 feet above the Thames near Southend-on-Sea, overlooking a dramatic drop to the estuary below. Constable paid it only one visit, with his friend the Reverend Walter Wren Driffield, vicar of Feering, Essex, in 1814. He made a drawing of this composition in a small sketchbook he was using at the time (now in the Victoria and Albert Museum, R.127). The course of his courtship of Maria Bicknell was then extremely discouraging and this no doubt led to his writing to her about the "melancholy grandeur of a sea shore." Maria's death in November 1828 seems to have caused him to recall these desolate associations, and he started to paint his large picture for the 1829 Academy exhibition from the drawing he had made fourteen years earlier. Shortly before the exhibition Constable received the news of his long-delayed election as a full Royal Academician. He gave the painting the title "Hadleigh Castle. The mouth of the Thames—morning after a stormy night" and added the lines by James Thomson:

> The desert joys
> Wildly, through all his melancholy bounds
> Rude ruins glitter; and the briny deep,
> Seen from some pointed promontory's top,
> Far to the dim horizon's utmost verge
> Restless, reflects a floating gleam.
> (*The Seasons*, "Summer," ll.165–170,
> as printed in the catalogue)

The choice of quotation shows that Constable saw in ancient ruins a symbol of melancholy, reinforced here by his personal experience of sadness.

There is a full-size oil sketch for this painting in the Tate Gallery (P.33).

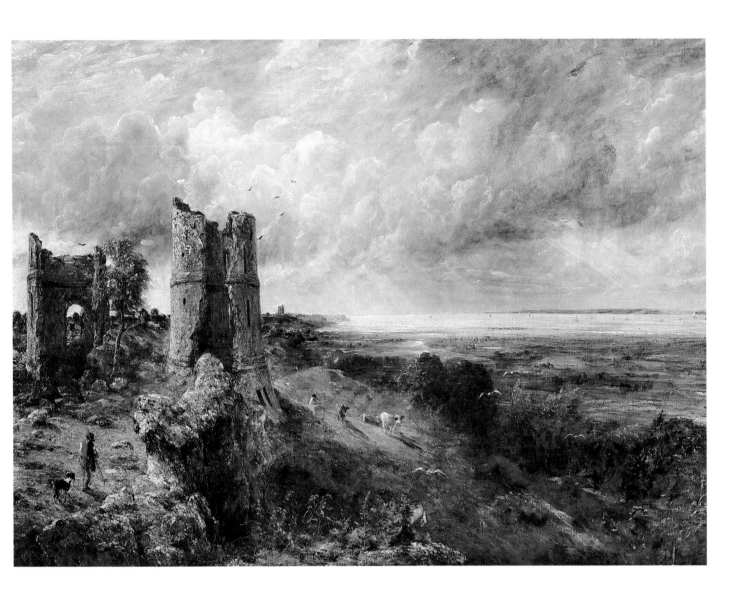

IX. STOKE-BY-NAYLAND AND HELMINGHAM, SUFFOLK

The beauty of the day (which perhaps might be the last this autumn) tempted me to take a walk to Neyland to pass the day with my poor Aunt, who is now a great invalid. My way was chiefly through woods and nothing could exceed the beauty of the foliage.

—Constable writing to Maria Bicknell
from East Bergholt, October 25, 1814
(JCC II, p. 134)

Here I am quite alone amongst the oaks and solitude of Helmingham Park.... There are abundance of fine trees of all sorts; though the place upon the whole affords good objects rather than fine scenery.

—Constable writing to John Dunthorne
senior, July 25, 1800 (JCC II, p. 25)

59. *Stoke-by-Nayland*

New York, The Metropolitan Museum of Art, Charles B. Curtis Fund, 1926 (26.128).
1810. Oil on canvas, 11⅛ x 14¼ in. (28.3 x 36.2 cm.).
The canvas has been extended by about an inch to the left by the unfolding of a strip from behind
the original stretcher.
COLL. Sedelmeyer; Aureliano de Beruete; Dario de Regoyos, 1926; bought, 1926.
LIT. H.140; Boston, 1946 (146).

Stoke-by-Nayland is some six miles from Flatford, and thus just outside Constable's immediate homeland. His main reason for visiting it seems to have been to see his old aunt Martha, or Patty, Smith, who lived at Nayland, the neighboring village from which this Stoke takes the name that distinguishes it from Stoke near Ipswich. In 1810 Aunt Patty commissioned Constable to paint an altarpiece for Nayland church, and at this time he made a number of drawings and sketches at Stoke-by-Nayland. Most of the drawings are in a sketchbook now in the Louvre (RF 11615); No. 59 is one of the oil sketches, and another is in the Tate Gallery (P.11).

The drawings and oil sketches—which, in their more advanced state, provided the subject of the mezzotint in *English Landscape Scenery*—explore in various combinations the relation of the church tower, the white, gable-ended cottage, the mass of trees on the left, and in some, though not in this one, a girl carrying a load of faggots.

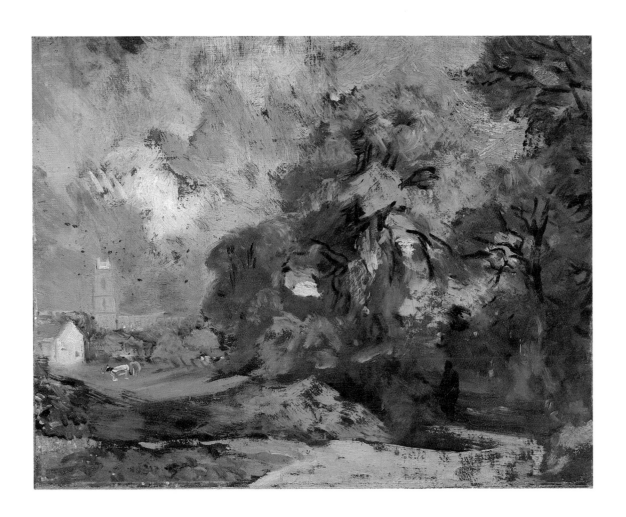

60. Stoke-by-Nayland

The Art Institute of Chicago, Mr. and Mrs. W. W. Kimball Collection (1922.4453).
?1835. Oil on canvas, 49⅝ x 66½ in. (126 x 168.8 cm.).
COLL. Perhaps the artist's sale, Foster's, May 15–16, 1838 (40); Ivy; Miss Morris; Nield sale, 1879; Sir F. T. Mappin, 1919; Mrs. W. W. Kimball; bequeathed by her, 1922.
LIT. H.564; Chicago/New York, 1946–47 (44); New York/St. Louis/San Francisco, 1956–57 (27), pp. 30, 33.

It was about twenty years before Constable returned to the sketches, such as No. 59, that he had made at Stoke-by-Nayland in 1810. His original motive was to include a typical Suffolk church in his choice of subjects for *English Landscape Scenery*. Lucas's mezzotint was begun, as one of the earliest plates, in 1829, and after many alterations in the plate was published in the second number in 1830.

Constable later reverted to the theme as a subject for a large canvas. In a letter to William Purton, probably written in July 1835, he said:

> I am glad you encourage me with "Stoke". What say you to a summer morning? July or August, at eight or nine o'clock, after a slight shower during the night, to enhance the dews in the shadowed part of the picture, under
>
> > "Hedge row elms and hillocks green."
>
> Then the plough, cart, horse, gate, cows, donkey, &c are all good paintable material for the foreground, and the size of the canvas sufficient to try one's strength, and keep one at full collar. (JCC V, p. 44)

C. R. Leslie mistakenly stated in his biography of Constable (1843) that the picture the artist described so fully was not painted, and this has sometimes led the authenticity of No. 60 to be questioned. But such doubts are unwarranted. The painting is a spectacular example of Constable's last manner, when the "broken ruggedness" of his style was being modified by a warmer palette. In the final years of his life he was emerging from the gloom so tempestuously expressed in such works as *Hadleigh Castle* (No. 58) and adopting a richer, less naturalistic form of coloring, seen also in the late sketch *On the Stour* (No. 26). That he was conscious of a change of mood is reflected in the difference between the mezzotint of 1830 and this painting. The engraving showed the church at a summer's noon, under thunderclouds and with a rainbow. Here the sun, bringing more light into the right-hand mass of trees, is further to the east and the time earlier in the day, in accordance with Constable's more optimistic feelings, conveyed in his description of the scene to Purton. The picture also embodies all the "paintable material" he proposed for the foreground. The plow is based upon an oil sketch of 1814 (fig. 18), to which Constable had referred when painting the plow in *The Cornfield* (No. 23).

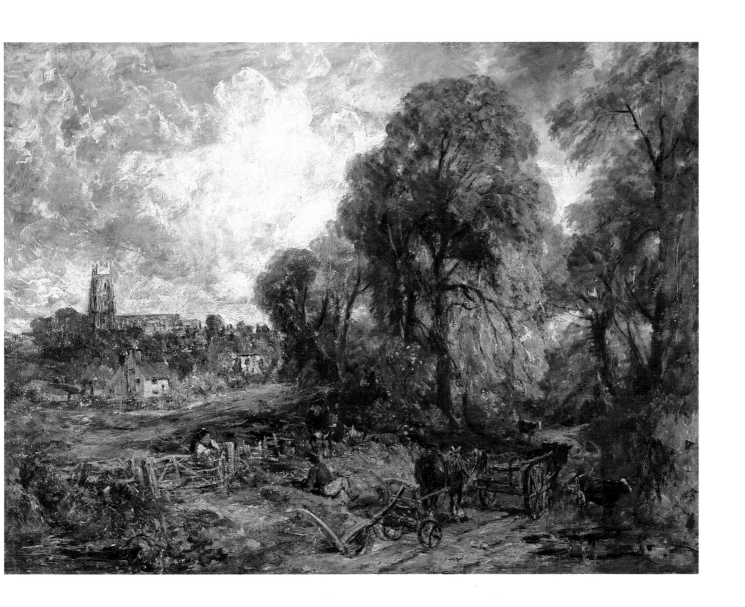

61. Helmingham Dell

Philadelphia, The John G. Johnson Collection (J.871).

1825–26. Oil on canvas, 27⅞ x 36 in. (70.8 x 91.4 cm.).

The canvas is on the original stretcher, which bears the stencil of the Scovell sale. A label fixed to the top member of the stretcher is inscribed in ink by the artist: *John Constable 35 Charlotte Street*. The bottom member is inscribed in ink: *A Dell in Helmingham Park*; according to the archives of the John G. Johnson Collection, this was followed by: *painted by John Constable 1826*, but this is not now visible.

EXH. British Institution, 1833 (156).

COLL. Painted 1825–26 for·James Pulham; bought back from Pulham's widow by Constable, 1830; given by him to Robert Ludgate, 1833; auctioned by his widow, Christie's, June 29, 1833 (not in printed catalogue); Charles Scovell, 1833; by descent to J. Scovell; his sale, Christie's, June 8, 1883 (243); Fielder, 1883; John G. Johnson, by 1914.

LIT. H.548; Boston, 1946 (141); R. B. Beckett, "Constable's 'Helmingham Dell,'" *Art Quarterly*, XXIV, 1961, pp. 2–14; Tate, 1976 (295).

During the solitary visit to Helmingham Park that he described in the letter to Dunthorne quoted at the beginning of this section, Constable made a large, careful line-and-wash drawing of this composition, dated July 23, 1800 (Clonterbrook Trustees). Helmingham was then owned by Wilbraham, sixth earl of Dysart; Constable was not apparently known to the earl at the time, though he subsequently became acquainted with him and other members of the family, including Henry Greswolde Lewis, the owner of Malvern Hall in Warwickshire (see No. 28). In spite of these friendships Constable does not seem to have returned to sketch in the park, and both Nos. 61 and 62 are based upon the drawing of 1800. This version was painted in 1825–26 for a Suffolk patron, James Pulham, a solicitor of Woodbridge who had associations with Helmingham. After buying the picture back from his widow (Constable's portrait of Mrs. Pulham, painted in 1818, now hangs in the Metropolitan Museum), Constable did a considerable amount of repainting upon it and sent it for exhibition to the British Institution in 1833. In the same year, it was hastily included in the auction following the death of its new owner, Robert Ludgate; its authenticity was doubted and it was sold to Charles Scovell for a derisory price. Many years later its authenticity was again doubted and Scovell's descendants were able to prove that the picture was genuine by producing a letter that Constable had written in November 1833 confirming that it was his work (JCC IV, pp. 104–105).

In this version the only living presences are the red-cloaked woman approaching the footbridge on the left, and the heron in the foreground.

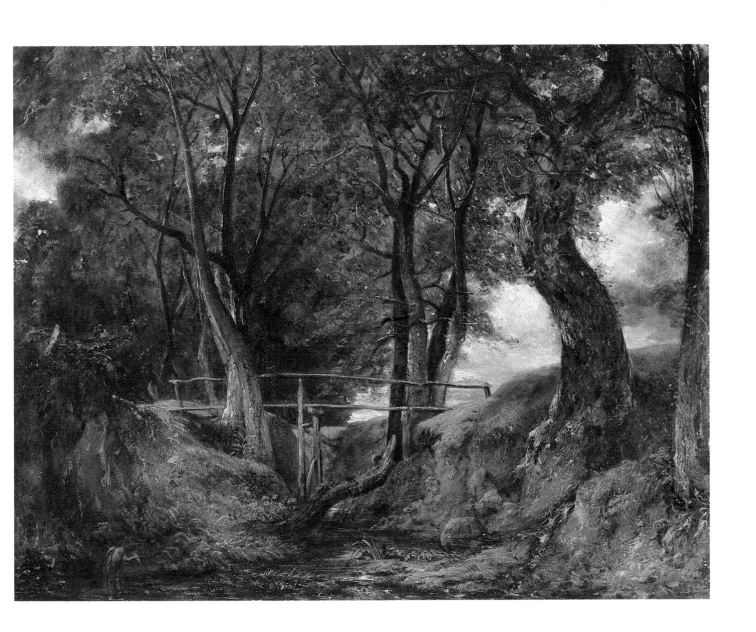

62. Helmingham Dell

Kansas City, Nelson Gallery-Atkins Museum, Nelson Fund (55.39).
1830. Oil on canvas, 44⅝ x 51½ in. (113.3 x 130.8 cm.).
The canvas has been extended at the top by some 2 inches originally turned round the stretcher.
Engraved in mezzotint by David Lucas and published in the first part of *English Landscape Scenery*, 1830.
EXH. Royal Academy, 1830 (19).
COLL. Painted for James Carpenter in substitution for *A Boat Passing a Lock* (No. 24), but withheld; the artist's sale, Foster's, May 15–16, 1838 (73); Allnutt, 1838; F. T. Rufford, 1857; Henry McConnell, 1862; Christie's, March 27, 1886 (66); S. White, 1886; J. M. Keiller, 1886; Knoedler, 1928; J. J. Hill; W. Butterworth; Katherine D. Butterworth; Parke-Bernet, October 20, 1954 (33); Knoedler; bought, 1955.
LIT. H.530; R. B. Beckett, "Constable's 'Helmingham Dell,'" *Art Quarterly*, XXIV, 1961, pp. 2–14.

Constable painted this larger version of No. 61 four years later. It was intended to replace *A Boat Passing a Lock* (No. 24), which had been commissioned by James Carpenter but which Constable chose to give as his Diploma picture to the Royal Academy. In the event Constable canceled this revised commission, affronted by Carpenter's wish to pay him with books and secondhand furniture, and believing that the other did not really like his paintings. Instead he sent it to the Royal Academy's summer exhibition; it remained unsold till his death.

As well as being half as large again in its dimensions, this later version differs from its predecessor in many of the details of the staffage. A stag with large antlers is seen against the light on the right, and a cow is watering in the left foreground.

The two versions of *Helmingham Dell*, Nos. 61 and 62, are exceptional in Constable's work in showing an enclosed woodland scene with only a small glimpse of sky. In that respect they anticipate *The Cenotaph* (National Gallery, London), which he exhibited at the Royal Academy in 1836 as a memorial to Sir Joshua Reynolds and Sir George Beaumont.

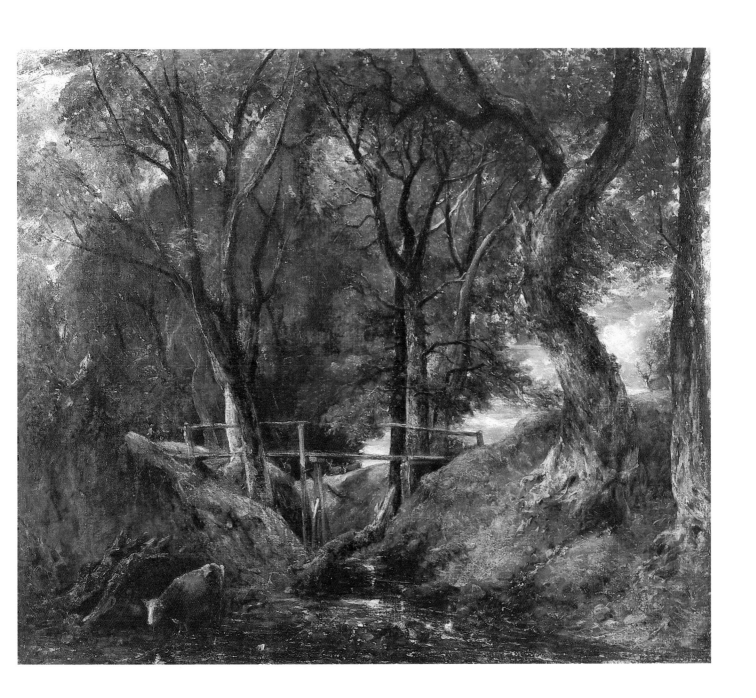

X. ARUNDEL, SUSSEX

The Castle is the chief ornament of this place — but all here sinks to insignificance in comparison with the woods, and hills. The woods hang from excessive steeps, and precipices, and the trees are beyond everything beautiful: I never saw such beauty in natural landscape *before. I wish it may influence what I may do in future, for I have too much preferred the picturesque to the beautiful — which will I hope account for the* broken ruggedness of my style.

—Constable writing to C. R. Leslie
from Arundel, July 16, 1834
(JCC III, p. 111)

63. Sketch for *Arundel Mill and Castle*

The Fine Arts Museums of San Francisco, Mildred Anna Williams Collection (1940.24).
?1835. Oil on board, 11⅝ x 16 (29.5 x 40.6 cm.).
Inscribed in ink on the back of the board: *This picture was painted by John Constable R.A. and was presented to my father. The picture is mentioned in Leslie's Life of Constable and from which Mr. Constable painted his last and large picture. Geo. S. Constable.*
COLL. Given by the artist to George Constable; by descent to his son, George S. Constable; S. G. Holland; his sale, Christie's, June 25, 1908 (14); Colnaghi, 1908; Knoedler; Mrs. M. A. Williams; given by her, 1940.
LIT. H.701.

When, at the suggestion of his eldest son, John Charles, Constable decided to make a large painting of Arundel Mill and Castle (No. 64), he wrote to his host George Constable of Arundel: "Can you bring with you...the sketch I made of your mill—John wants me to make a picture of it" (December 16, 1835; JCC V, p. 28). From the inscription on the back of this sketch, written by George Constable's son, George S. Constable, it must be the one to which the artist was referring. The sketch is also mentioned by George S. Constable in a letter of November 7, 1883: "I have in my possession some small pictures painted by Constable ...among them the last sketch from nature Constable painted 'The Old Water Mill at Arundel'. He painted it on the spot and gave it to my Father." When executing No. 64 Constable relied mainly on this oil sketch but referred for some details to his pencil drawings of July 1835 (Victoria and Albert Museum, fig. 9 and R.382).

After Constable's death George Constable was detected unaccountably passing off his copies of the artist's sketches as original. But what is known of George Constable's work shows that No. 63 is totally outside his compass. Although Hoozee rejects it as an imitation, the sketch is evidently authentic, both from its history and on stylistic grounds. It is a typical, fine example of Constable's last manner.

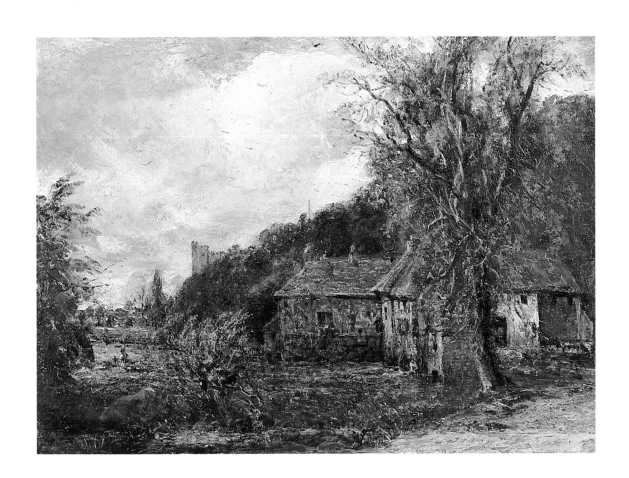

64. Arundel Mill and Castle

The Toledo Museum of Art, Ohio, Gift of Edward Drummond Libbey (26.53).
1837. Oil on canvas, 28½ x 39½ in. (72.4 x 100.3 cm.).
EXH. Royal Academy, 1837 (193).
COLL. The artist's sale, Foster's, May 15–16, 1838 (81); bought in for John Charles Constable; Capt. Charles Golding Constable; Holbrook Gaskell, 1878; his sale, Christie's, June 24, 1909 (8); Knoedler, 1909; Edward Drummond Libbey, 1909; given by him, 1925.
LIT. *The Toledo Museum of Art: European Paintings,* Toledo, Ohio, 1976, pp. 39–40; H.565; Boston, 1946 (147); Tate, 1976 (335).

Constable was introduced to the scenery of inland Sussex in 1834 by a new friend, George Constable, a brewer and amateur artist of Arundel. He stayed in Sussex again that year, this time with Lord Egremont at Petworth, and paid a second visit to George Constable at Arundel in the following July. On this occasion he made a number of drawings of Arundel Castle and the mill on Swanbourne Lake below it (fig. 9). The oil sketch (No. 63) probably dates from this visit.

Constable was always attracted by old mills, and the scene also appealed to his eldest son, John Charles, who had accompanied him. At his son's suggestion he began to paint this larger picture of the mill with the castle behind it; he had intended to show it at the Royal Academy exhibition of 1836 but decided instead upon *The Cenotaph* (National Gallery, London). He was working upon the painting on the day he died, March 31, 1837, and his friends considered that it was sufficiently finished to be shown posthumously at the Academy that May, in the first exhibition to be held in the new rooms in Trafalgar Square.

John Charles Constable showed his continuing enthusiasm for the painting by buying it back at the sale of contents of his father's studio.

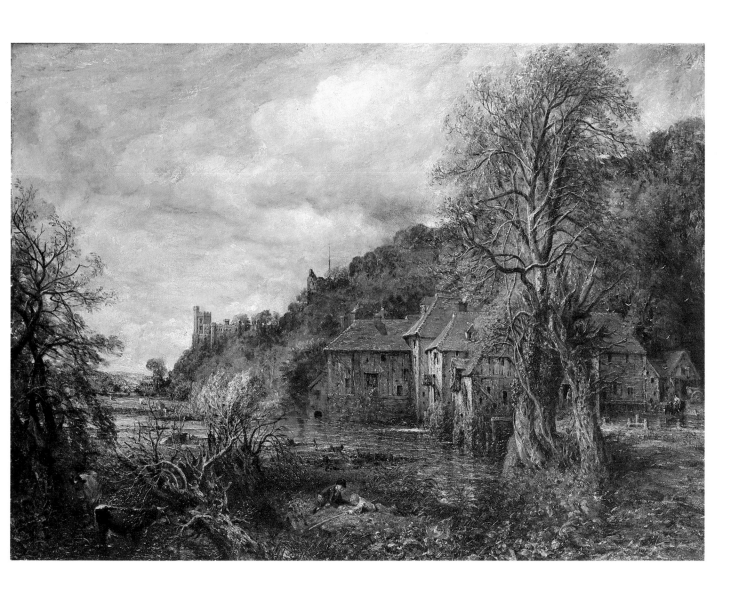

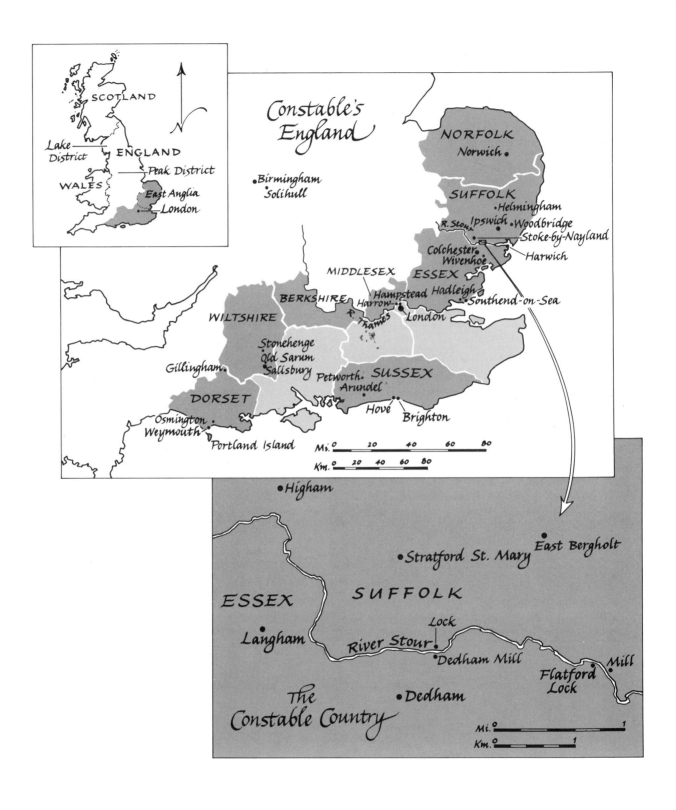

Constable's England

SCOTLAND

Lake
District

ENGLAND

WALES

Peak District

East Anglia

London

•Birmingham
•Solihull

NORFOLK
Norwich•

SUFFOLK
•Helmingham
R. Stour• Ipswich• Woodbridge
•Stoke-by-Nayland
Colchester• Harwich
Wivenhoe•

MIDDLESEX
ESSEX
Hampstead Hadleigh•
BERKSHIRE Harrow• •Southend-on-Sea
London•
WILTSHIRE R. Thames

Stonehenge
Old Sarum SUSSEX
Gillingham• •Salisbury Petworth• •
•Arundel

DORSET Hové• •Brighton

Osmington•
Weymouth•
Portland Island•

Mi. 0 20 40 60 80
Km. 0 20 40 60 80

•Higham

•Stratford St. Mary •East Bergholt

ESSEX SUFFOLK

Lock
•Langham River Stour•
•Dedham Mill
Flatford •Mill
Lock
•Dedham

The
Constable Country

Mi. 0 1
Km. 0 1

BIOGRAPHICAL SUMMARY

1776

John Constable was born in East Bergholt, Suffolk, on June 11, the fourth child and second son of Golding Constable, a well-to-do mill owner, and Ann, née Watts. His early fondness for painting was encouraged by his friendship with John Dunthorne senior (1770–1844), a plumber and glazier of East Bergholt, who was an amateur painter. Others who encouraged him were the connoisseur and patron Sir George Beaumont, Bart. (1753–1827), himself a gifted artist, and Dr. John Fisher (1748–1825), later bishop of Salisbury.

1796

While staying with relatives at Edmonton met the draughtsman and etcher J. T. ("Antiquity") Smith (1766–1833), and under his influence made drawings of picturesque cottages.

1799

Came to London in February with a letter of introduction to Joseph Farington, R.A. (1747–1821), resolved to leave the family business and become a professional painter. Farington, whose Diary remains one of the principal sources for the history of English art in his day, was an influential figure in the contemporary art world and was to take an interest in the younger man's career. Constable entered the Royal Academy Schools as a probationer in March.

1800

Enrolled as a student of the Royal Academy Schools in February; his curriculum included studies from the antique, the nude model, and anatomical drawings. In the summer sketched in Helmingham Park (see Nos. 61, 62), the Suffolk estate of the earl of Dysart.

1801

Painted his first considerable commission, a view of Old Hall, East Bergholt, for its then owner, John Reade. Went on a sketching tour of the Peak District, Derbyshire, in August.

1802

Exhibited at the Royal Academy for the first time, his entry being an unidentified "Landscape." Visited Windsor in May and was at East Bergholt in the summer and autumn. Declared in a letter to Dunthorne his intention of becoming "a natural painter." Bought a studio in East Bergholt, near his parents' house.

1803

Exhibited four landscapes at the Royal Academy. In April sailed from London to Deal, Kent, in the East Indiaman *Coutts*, making many drawings of shipping, influenced by the marine paintings of Van de Velde. Spent the summer in East Bergholt.

1804

Constable did not exhibit this year. According to Farington, he spent much of his time at East Bergholt painting portraits of the local farmers and their wives; he also visited Hampshire. Saw Sir George Beaumont's *Château de Steen* by Rubens for the first time.

1805

Exhibited one landscape at the Royal Academy. Was commissioned to paint an altarpiece for Brantham church in Suffolk.

1806

A watercolor of the battle of Trafalgar (1805) was

his only exhibit at the Royal Academy this year. Staying with the Hobsons at Tottenham in July he made many drawings of the family. A visit of some two months to the Lake District in the autumn resulted in numerous pencil and watercolor studies of mountain scenery (see fig. 1); he began to make records of the weather on these drawings.

1807

Spent most of this year in London, and copied portraits by Reynolds and Hoppner for Lord Dysart. His three exhibits at the Royal Academy were of Lake District scenes.

1808

Again exhibited three Lake District scenes at the Royal Academy. Visited East Bergholt in the summer.

1809

Visited Epsom, Surrey, and there and in East Bergholt made some sketches which reveal the progress of his style towards freedom of expression. He also stayed at Malvern Hall, Solihull, Warwickshire (see No. 28), as a guest of Henry Greswolde Lewis, brother of the dowager countess of Dysart. At East Bergholt in the autumn met and fell in love with Maria Bicknell (1788–1827). Daughter of Charles Bicknell, solicitor to the Admiralty, she was then staying with her maternal grandfather, Dr. Durand Rhudde, rector of East Bergholt.

1810

Exhibited two landscapes, one of East Bergholt church, at the Royal Academy, and was engaged in painting his second altarpiece (for Nayland church in Suffolk).

1811

Among his exhibits at the Royal Academy was a panoramic view of Dedham Vale. Visited Salisbury for the first time in September, as a guest of

the bishop, Dr. Fisher. This was probably the occasion of his first meeting with the bishop's nephew and namesake, the Reverend John Fisher (1788–1832), later archdeacon of Berkshire, who was to become his closest friend. Constable's attachment to Maria Bicknell was made known during the year, and in October he received her father's permission to write to her; but the engagement was protracted owing to Dr. Rhudde's opposition.

1812

His exhibits at the Royal Academy included *Flatford Lock and Mill* (No. 9). Spent most of the summer in Suffolk; his open-air sketching reveals the renewed influence of Rubens.

1813

Exhibited at the Royal Academy *Landscape: Boys Fishing* (a view of the Stour from Flatford Lock) and a second landscape. Spent most of the summer and autumn in Suffolk, filling a small sketchbook with drawings of the countryside.

1814

Exhibited at the Royal Academy *Landscape: Ploughing Scene in Suffolk* and *Landscape: The Ferry*. In June, while staying at Feering, Essex, he visited Hadleigh Castle (see No. 58). Spent much of the rest of the year in Suffolk, filling another small sketchbook (see figs. 13–16), in which he made preparatory designs for *The Stour Valley and Dedham Village* (No. 15), painted this year.

1815

Five paintings and three drawings exhibited at the Royal Academy, including probably *The Stour Valley and Dedham Village* (No. 15). His mother died early this year and he was in Suffolk in May. Left London again for Suffolk in July and remained there most of the rest of the year, being detained during December by his father's serious illness.

1816

Exhibited two landscapes at the Royal Academy. His father died in May. Spent some of the summer in Suffolk and paid two visits to Wivenhoe, Essex, where he was commissioned to paint the house and grounds of Major-General Francis Slater-Rebow (No. 27). The long engagement between himself and Maria Bicknell was now at an end; they were married by the younger John Fisher on October 2 in St. Martin-in-the-Fields, London, and spent part of their honeymoon staying with Fisher at his vicarage in Osmington, Dorset. It was on this visit that Constable sketched the environs of Weymouth Bay (see fig. 4 and No. 29).

1817

Exhibited four works at the Royal Academy, including *Wivenhoe Park, Essex* (No. 27) and a portrait of John Fisher. In London moved into 1 Keppel Street. Spent ten weeks of the summer at East Bergholt with his wife. Their first child, John Charles, was born on December 4.

1818

Exhibited at the Royal Academy four landscapes and two drawings. Did a certain amount of sketching in the Home Counties, including Windsor.

1819

The first of his six-foot Stour scenes, *The White Horse*, exhibited at the Royal Academy; it was bought by John Fisher. His second child, Maria Louisa (Minna), born on July 19. He took a house at Hampstead for the first time at the end of the summer, and from then on scenes of that district figured largely in his work. Elected Associate of the Royal Academy on November 1.

1820

Second large Stour scene, *Stratford Mill*, exhibited at the Royal Academy, together with *A View*

of Harwich Lighthouse. With Maria and their two children stayed in July and August with John Fisher and his wife in their house at Salisbury; made numerous drawings and some oil sketches of the cathedral and neighborhood (Nos. 31, 32). After settling his family at Hampstead, stayed briefly at Malvern Hall (see No. 28), first visited in 1809.

1821

The chief of Constable's four exhibits was his third large Stour scene, *The Hay Wain*. His third child, Charles Golding, was born on March 29. Accompanied Fisher on his visitation of Berkshire as archdeacon in June, and paid him a visit at Salisbury in November. It was in this year that he began his "skying," the systematic study of changing skies (see figs. 5–7; Nos. 39, 40).

1822

Exhibits at the Royal Academy included his fourth large Stour scene, *View on the Stour near Dedham* (fig. 17; see No. 19), and two Hampstead subjects. His fourth child, Isabel, was born on August 23. Again actively engaged in making cloud studies at Hampstead (Nos. 43, 44). His connection with the French dealer John Arrowsmith began this year. Moved into Farington's old house at 35 Charlotte Street (Farington having died the previous year), and this remained his London home till his death.

1823

Constable's chief exhibit at the Royal Academy was *Salisbury Cathedral from the Bishop's Grounds* (see Nos. 31, 34). Visited Fisher at Salisbury in August. Stayed with Sir George Beaumont at Coleorton in Leicestershire from the last week in October until the end of November, studying intensively his host's fine collection of Old Masters and making careful copies of two of his Claudes.

1824

His sole exhibit at the Royal Academy was his fifth large Stour scene, *The Lock* (see No. 21). *The Hay Wain, View on the Stour near Dedham* (fig. 17; see No. 19), and a view of Hampstead Heath were exhibited at the Salon in Paris; they were greatly acclaimed by the French artists, particularly Delacroix, and were awarded a gold medal by Charles X. Advised to try the sea air for his wife's health, Constable took Maria and the children to Brighton for the first time in May, and himself spent some time in London and some with the family at Brighton.

1825

Three paintings called "Landscape" exhibited at the Royal Academy: one was the sixth large Stour scene, *The Leaping Horse*; the other two were views of Hampstead Heath, one of them being No. 45. His fifth child, Emily, was born on March 29. *The White Horse* and another painting were exhibited at Lille; he was again awarded a gold medal.

1826

Exhibited at the Royal Academy *The Cornfield* (No. 23) and *A Mill at Gillingham in Dorsetshire* (see No. 30). The Constables' sixth child, Alfred Abram, was born on November 14.

1827

Exhibited *Marine Parade and Chain Pier, Brighton* (fig. 8), *Mill, Gillingham, Dorset*, and *Hampstead Heath* at the Royal Academy; *The Cornfield* (No. 23) at the Paris Salon; and a version of *The Glebe Farm* (see No. 25) at the British Institution. With John and Minna, his eldest children, stayed with his relatives at Flatford in the autumn, and made a number of drawings. This year he took the house in Well Walk which remained his Hampstead home till the end of his life.

1828

Exhibited at the Royal Academy two paintings called "Landscape": one was *Dedham Vale*, the other *Hampstead Heath* (see No. 46). His seventh child, Lionel Bicknell, was born on January 2. Constable inherited a fortune on the death of his father-in-law, Charles Bicknell, in March. Maria's health was now rapidly declining, and he took her on a last visit to Brighton in July. She died of pulmonary tuberculosis in Hampstead on November 23, aged forty-one. Constable never fully recovered from the loss.

1829

Elected a Royal Academician on February 10; presented as his Diploma painting *A Boat Passing a Lock* (No. 24). Exhibited *Hadleigh Castle* (No. 58) and a landscape of a "rich cottage" at the Royal Academy. In this year he formulated his plans for a series of mezzotints by David Lucas after his paintings, later published in parts as *English Landscape Scenery* (see figs. 11, 12). Paid his last two visits to Fisher at Salisbury in July and November.

1830

As a member of the hanging committee of the Royal Academy, witnessed the rejection of his *Water-Meadows near Salisbury* as a "nasty green thing." His accepted exhibits were views of Helmingham Park (No. 62) and Hampstead Heath, and another landscape. The first number of *English Landscape Scenery*, containing four plates, appeared in the summer.

1831

Exhibited *Salisbury Cathedral from the Meadows* and *Yarmouth Pier* at the Royal Academy. Took his daughters to stay with his relatives in Suffolk in July.

1832
Showed the unusually large number of eight exhibits at the Royal Academy, including *The Opening of Waterloo Bridge* (No. 57). His closest friend, John Fisher, died on August 25. He was in East Bergholt in July and again for the funeral of his studio assistant, John Dunthorne junior, son of his boyhood companion, in November.

1833
Among the four oil paintings and three drawings exhibited at the Royal Academy were *Englefield House, Berkshire* and *The Cottage in a Cornfield*. Gave his first lecture on the history of landscape painting, at Hampstead.

1834
Constable had no oils at the Royal Academy this year, owing to illness. The three watercolors he showed included *Old Sarum*, a composition adapted from No. 36. Paid his first visit to George Constable at Arundel in July, accompanied by his eldest son, John Charles, and stayed with Lord Egremont at Petworth in September; on both occasions he made many drawings and watercolors of the Sussex countryside.

1835
The Valley Farm (in the Tate Gallery) was his sole exhibit at the Royal Academy. With his two eldest children, paid a second visit to George Constable in Arundel (see fig. 9 and No. 63). Lectured in Worcester in October.

1836
This was the last occasion on which the Royal Academy's annual exhibition was held at Somerset House. Constable sent two works, *The Cenotaph* and the watercolor *Stonehenge*. Gave his lectures on the history of landscape painting in their definitive form at the Royal Institution in May and June.

1837
Died suddenly on March 31. On the day of his death he had been working on *Arundel Mill and Castle* (No. 64) in preparation for the Royal Academy, and it was shown posthumously at the first exhibition held at the National Gallery's building in Trafalgar Square. Constable was buried with his wife in the churchyard of St. John's, Hampstead.

FURTHER READING

In addition to titles listed under Abbreviations, the following books are suggested as further reading on the subject of John Constable's life and work.

Constable, Freda. *John Constable: A Biography — 1776–1837*. Lavenham: Dalton, 1975.

Fleming-Williams, Ian. *Constable: Landscape Watercolours and Drawings*. London: Tate Gallery, 1976.

Gadney, Reg. *Constable and His World*. London: Thames and Hudson, 1976.

Leslie, C. R. *Memoirs of the Life of John Constable, R. A., Composed Chiefly of His Letters*. London, 1843; 2nd rev. ed., 1845. Among the many later editions one of the most accessible is that edited by Jonathan Mayne (London: Phaidon, 1951; paperback ed., 1980).

Reynolds, Graham. *Constable: The Natural Painter*. London: Evelyn, Adams and Mackay, 1965; paperback eds., 1969, 1970, 1976.

Smart, Alastair, and Brooks, Attfield. *Constable and His Country*. London: Elek, 1976.

Taylor, Basil. *Constable: Paintings, Drawings and Watercolours*. London: Phaidon, 1973; rev. ed., 1975.

The following are facsimiles of sketchbooks by Constable.

Victoria and Albert Museum. *John Constable's Sketch-books of 1813 and 1814*. Introduction by Graham Reynolds. London: Her Majesty's Stationery Office, 1973.

Constable with His Friends in 1806. Four sketchbooks in the Musée du Louvre, three by John Constable and one attributed to Lionel Bicknell Constable. Introduction and commentary by Graham Reynolds. Paris/Guildford/San Francisco: Trianon Press and Genesis Publications, 1981.